Margaret Willes

PICK

of the

BUNCH

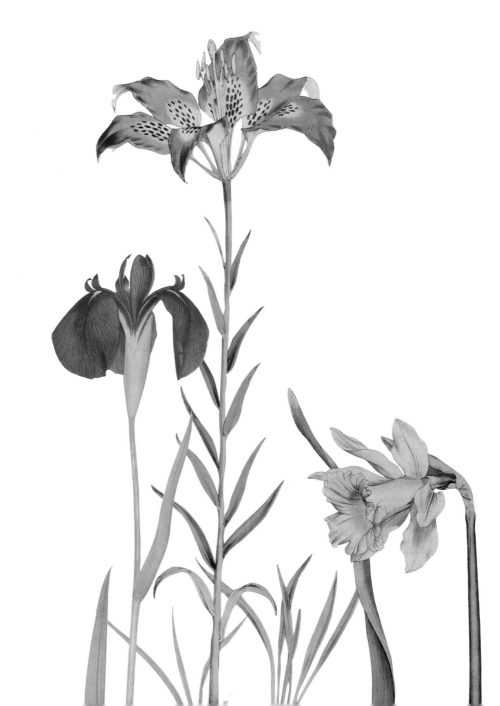

Margaret Willes

PICK
of the
BUNCH

The Story of Twelve Treasured Flowers

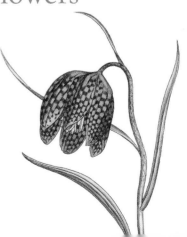

Bodleian Library
UNIVERSITY OF OXFORD

To the Herbal Cats

First published in 2009 by the Bodleian Library
Broad Street
Oxford OX1 3BG

www.bodleianbookshop.co.uk

ISBN: 978 1 85124 303 7

Text © Margaret Willes 2009
Images © Bodleian Library, University of Oxford, 2009, with the exception of *Vase of Flowers* by
Ambrosius Bosschaert, *c.*1609 © Ashmolean Museum, Oxford. Reproduced by permission of the
Ashmolean Museum, Oxford.

Cover design by Dot Little
Designed by Dot Little
Layout by Sophie Durand
Printed and bound by Great Wall Printing, China
British Library Catalogue in Publishing Data
A CIP record of this publication is available from the British Library

Contents

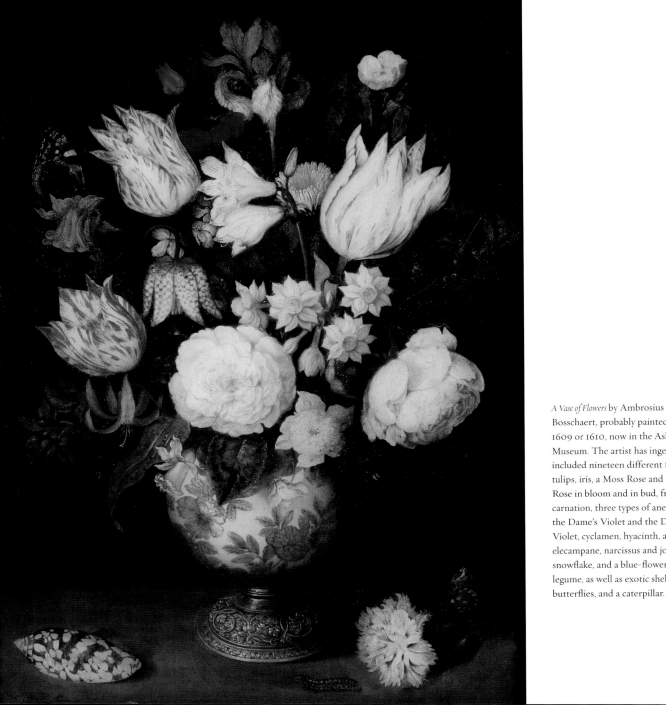

A *Vase of Flowers* by Ambrosius Bosschaert, probably painted in 1609 or 1610, now in the Ashmolean Museum. The artist has ingeniously included nineteen different flowers: tulips, iris, a Moss Rose and a Dog Rose in bloom and in bud, fritillary, carnation, three types of anemone, the Dame's Violet and the Dogstooth Violet, cyclamen, hyacinth, aquilegia, elecampane, narcissus and jonquil, snowflake, and a blue-flowered legume, as well as exotic shells, butterflies, and a caterpillar.

Introduction

Some of the finest flower-pieces ever painted were by Dutch and Flemish artists in the seventeenth century. Exquisite pictures were produced of cut flowers in vases of metal and porcelain, sometimes with insects and butterflies nestling in petals or clinging to stalks. The flowers depicted in these paintings came from different seasons, so that these are fantasies that could never have existed in nature at the time, before the technological miracles of hothouses and refrigeration. What the artists were seeking was a record of favourite flowers, brought together in this visual treat that could be savoured through the winter months. These paintings were commissioned and hung in the fine houses of rich merchants, who were enjoying the unprecedented wealth of world trade, and spending large sums on bulbs and flowers for their gardens.

From these flower-pieces we can see what Europeans of the time considered desirable flowers: the rose, iris, carnation, and lily, old favourites redolent of the Middle Ages and religious symbolism; the snowdrop, violet, and fritillary, 'natural' flowers of the meadow and woodland; and the tulip and hyacinth, fashionable bulbs that could command huge sums. It is fascinating, therefore, to identify the favourite flowers of today and to find that not much has changed. In 2002, the BBC conducted a reader poll, and found that the rose is the all-time-favourite flower, followed by the lily, the primrose, the iris, and the daffodil. The snowdrop, fritillary, tulip, narcissus, and hyacinth are shown in the same poll to be the favourite flowering bulbs.

In this book, I have taken twelve of these favourite flowers, and looked at their social history, how they acquired their names, how they arrived in our gardens, how they were portrayed by artists, how they were bought, obtained, and displayed, and who were their devotees. I have taken as my starting

point a flower-piece, now in the Ashmolean Museum, by one of the greatest exponents of the art of botanical painting, Ambrosius Bosschaert. The painting, in oil on copper, was probably painted around 1610 when Bosschaert was living in the Dutch town of Middelburg. The flowers, which would have bloomed between April and July, are arranged in a gilt-mounted porcelain vase. Nine of the flowers that I have featured in the book are shown in the painting. The three that are not there are the auricula, the lily, and the dahlia. The auricula, which had been brought to Holland by the great botanist Clusius twenty years before, is rarely shown in flower-pieces, but appears more often by itself in a pot. The dahlia, though seen in Mexico in the 1570s by the Spanish physician Francisco Hernández, was not introduced to Europe until the very end of the eighteenth century. The surprising omission is the lily, although it does appear as a crowning feature in a painting now in a private collection that is thought to be a companion piece to the Ashmolean picture.

At the time that Ambrosius Bosschaert produced his painting, in the first years of the seventeenth century, gardeners throughout Europe were aflame with excitement about the new varieties of plants that were arriving from the Middle East, Asia, Africa, and the Americas. In Bosschaert's home, Middelburg, the townspeople were noted as connoisseurs of flowers and were known as *liefhebbers*. One remarkable Middelburger, Jehan Somer, set off for a tour of the Mediterranean and the Levant in 1590. It was not an easy journey. Obliged to use crutches to walk, he first nearly drowned after drinking too much beer, and then his ship was captured by Turks and he was forced into slavery on a galley. In Alexandria he was rescued by the French consul and went on his way to the Holy Land and Constantinople, where he discovered his passion for rare flowers. On his return home he brought with him Dogstooth Violets, auriculas, double narcissi, lilies, small tulips, and crocuses, and in 1597 he wrote to Clusius offering him an offset of a Martagon Lily acquired in Constantinople. In return he requested 'two, three or four of your beautiful colours of tulips, yes, even if it were only one, for however small it is that comes from your honour's hand I shall receive with the greatest thanks'.

Clusius was then looking after the Botanic Garden at the University of Leiden. Botanic gardens attached to the medical faculties of universities had been established in Italy from the early sixteenth century to provide students with first-hand knowledge of the properties of plants. However, Clusius specified that the garden at Leiden, the first of its kind in Northern Europe, should contain over 1,000 species, one-third of which were of medical interest, while the remainder were exotics and ornamentals. He was, therefore, offering a laboratory where rare plants and cultivars might be propagated, providing a source of great interest to gardeners as well as botanists and medical practitioners.

Where Leiden and Clusius led, others followed: in 1621 a botanic garden was established in Oxford when Henry, Lord Danvers, who later became the Earl of Danby, gave £250 to the University and ground was leased from Magdalen College. According to the Oxford historian Anthony à Wood, the Earl wanted the great gardener, John Tradescant the Elder, to tend the garden, but deferred appointing a professor of botany because 'The Garden could not be soon enough furnished with Simples, and they with a maturity.' Tradescant only confirmed his acceptance as gardener in 1636, and two years later he was dead, so that it has been long thought that he had no part in the garden. Evidence, however, has recently been found showing that Tradescant had a servant in Oxford in 1637, suggesting that he may have cultivated the garden for one season. His successor was the German Jacob Bobart the Elder, who took on the task in 1642, just before the outbreak of civil war, and somehow managed to keep going despite not being paid (p. 42).

To prevent the low-lying land from flooding, Danby had the levels raised and walled the garden, commissioning a magnificent gateway from Nicholas Stone after a design by Inigo Jones, with the Earl's bearded bust crowning the portico. The original mission of the garden was to glorify God and to

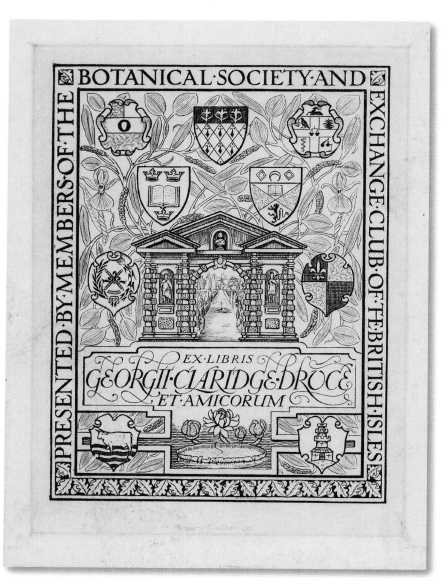

The book-plate presented in 1925 to George Claridge Druce by his friends in the Botanical Society of London. The design by Emery Walker provides a visual biography of Druce, with pride of place going to the Danby Gate of the Oxford University Botanic Garden.

promote learning through the advancement of the University's faculty of medicine, to which Danby left a generous bequest. Although the current layout of the walled garden was established in the nineteenth century, an engraving of 1675 by David Loggan shows a formal layout, with fruit trees planted against one of the walls and a glasshouse built in brick with a stone roof. Remarkably, a list of plants drawn up in 1648 has survived, giving a very clear picture of what Jacob Bobart was growing in the garden. Equally remarkable is the fact that the list contains 1,600 different plants that he had gathered during the six years of the garden's existence, and at a time of civil war.

A professor of botany was finally appointed in 1669, Robert Morison. Today, Cambridge is the university famous for its natural sciences, so it comes as a surprise that Oxford in the seventeenth century was ahead of the game. John Gerard had urged his patron, William Cecil, Lord Burghley, to establish a garden in Cambridge, but this came to nothing. Was Oxford's advantage due to the fact that the University enjoyed royal and court patronage? The institution that became the Royal Society of London for Improving of Natural Knowledge had begun as a series of informal meetings in Oxford and London from 1645, and played an important role in the development of botanical studies and publishing.

An intriguing cast of people involved in botany in Oxford make their appearance throughout this book, but two figures must be introduced here. William Sherard became a fellow of St John's College in 1677. Originally he read law, but even as an undergraduate he was a frequent visitor to the Botanic Garden, helping Jacob Bobart the Younger to complete Robert Morison's *Plantarum historiae universalis Oxoniensis* (p. 75). Taking advantage of his college's indulgence, Sherard paid visits to the Botanic Garden in Leiden, and to Paris, where he attended courses on botany given by the superintendent of the Jardin du Roi, Joseph Pitton de Tournefort. He later resumed his travels

on the Continent as tutor to young aristocrats, including the grandson of the keen horticulturalist
Mary, Duchess of Beaufort. On one such journey Sherard resolved to update a list that had been
made early in the seventeenth century of all the names given by botanical authors to each species of
plant known at the time. Some years later, he was able to turn his hand to creating a garden with his
brother James, who had made his fortune as an apothecary and bought an estate at Eltham. William
persuaded the German botanist Johann Jakob Dillenius to lodge with him in London and to help
him create a classified collection of preserved plants, known as a herbarium. In 1726 he donated
£500 towards the cost of enlarging the conservatory in the Botanic Garden in Oxford and, at his
death two years later, bequeathed to the University his herbarium of over 12,000 sheets, his library
of more than 6,000 volumes, and his paintings and drawings. He stipulated that a Sherardian chair
of botany should be established at the Botanic Garden, to be occupied by Dillenius for his lifetime,
and that the University should pay £150 annually towards the upkeep of the garden and its library.
This library, with his herbarium, is now in the University's Plant Sciences Department.

If Sherard was 'Gown', George Claridge Druce was definitely 'Town'. Born in 1850, the illegitimate
son of a Northamptonshire housekeeper, he served his apprenticeship with Philadelphus Jeyes in
Northampton before becoming a retail chemist in Oxford's High Street. He was such a prominent
figure in the city in the late nineteenth century that Max Beerbohm, who became an undergraduate
at Merton College in 1890, introduced him into his novel, *Zuleika Dobson*, where he bound up the
wounds of the Duke of Dorset after he took a tumble in the Turl. Druce made so much money
from his chemist's shop that he was able to retire in 1905 and to indulge his long-held passion for
botany. He produced surveys of the flora of four English counties, Northamptonshire, Berkshire,
Buckinghamshire, and Oxfordshire, a remarkable achievement. While writing his *Flora of Oxfordshire*, he
had made great use of the University's botanical collections, which included the herbaria of Sherard

and of Dillenius, and became their curator. In turn, he presented his own herbarium to the University with the bulk of his fortune at his death in 1932.

The majority of pictures reproduced in this book are from the collection in the Department of Plant Sciences, which is now part of the Bodleian Library. Other parts of the Bodleian also have fine collections of botanical books and herbals, including medieval manuscripts such as the Pseudo Apuleius Herbal and books of hours that have been decorated with exquisite paintings of flowers. The Radcliffe Science Library is based around the collection of books of John Radcliffe, court physician in the reign of Queen Anne. In his will of 1714, he earmarked the enormous sum of £40,000 for a library to be built next to the quadrangle of the Old Bodleian: the Radcliffe Camera still presides proudly on the site, though the books were moved to a building next to the University Museum in the nineteenth century.

The flower-piece that opens this book is from the Ashmolean, the first institution in England to be described as a museum. The collection was presented to the University by Elias Ashmole, and the Museum was opened in a building specially built for its accommodation in 1683 by the King's brother, James, Duke of York. But behind this munificent event lies a sorry tale. Half a century earlier, John Tradescant the Elder had opened to the public his collection known as the 'Ark' in his house in Lambeth. Tradescant had travelled widely in his horticultural endeavours and through his patron, the Duke of Buckingham, was able to enlist the help of merchants travelling to the Americas and to the Near East to bring back 'all manner of beasts and fowls and birds alive or if not with heads, horns, beaks, claws, skins, feathers; slips or seeds, plants, trees or shrubs'. For the admission fee of 6d. visitors were able to view these wonders, which included the skin of a Scythian lamb or borametz, the vegetable lamb from Tartary that was believed to grow like a plant with a stalk. John Parkinson gave this fabulous animal a place in the Garden of Eden on the title page to his *Paradisi in Sole*. In fact there

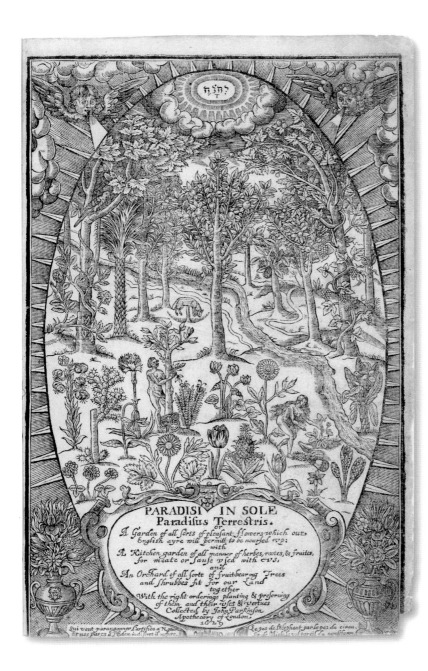

PARADISI IN SOLE
Paradisus Terrestris.
or
A Garden of all sorts of pleasant flowers which our
English ayre will permitt to be noursed vp:
with
A Kitchen garden of all manner of herbes, rootes, & fruites,
for meate or sause vsed with vs,
and
An Orchard of all sorte of fruitbearing Trees
and shrubbes fit for our Land
together
With the right orderinge planting & preseruing
of them and their vses & vertues
Collected by John Parkinson
Apothecary of London.
1629

Qui veut parangonner Iardins a Nature,
& nos parcs à l'Eden, ne li sort il nature.

Le pas de l'elephant parle pas du ciron,
& de Michilæ vol pareil du moucheron.

The title page to John Parkinson's *Paradisi in Sole, paradisus terrestris,* a pun on his own name, published in London in 1629. In the Garden of Eden Adam and Eve tend the plants that include the aster, the tulip, the pineapple, Martagon Lilies, and in the background, the borametz, or vegetable lamb, which feeds on the grass around its stalk.

Paradisi in Sole, Bodleian Antiq. c.E.1629

was a real plant, *Cibotium barometz*, a fern with a furry rhizome. It was through his guile as a lawyer that Elias Ashmole was able to gain legal title and control of the Ark from the widow of John Tradescant the Younger, so that it is his name that is attached to the collection. The leading figures in this drama are to be seen in portraits hanging in the Ashmolean Museum.

To trace the history of the different flowers I have used binomial names, a system first consistently applied by the Swedish botanist Carl Linnaeus in *Species plantarum* published in 1753. This marked the culmination of a long search for a system that could be universally adopted to demolish the Tower of Babel that had gradually built up to the exasperation of botanists and the alarm of physicians and apothecaries. Of course, Linnaeus did not pluck his system out of the ether, but built on the work of many botanists and naturalists, especially of the late seventeenth century. One important contribution was the work of Tournefort, superintendent of Louis XIV's Jardin du Roi in Paris.

In his *Elemens de botanique*, published in 1694, Tournefort analysed the different components of plants, focusing in particular on the shape of the petals. Linnaeus, on the other hand, recognized the significance of the sexuality of plants. He was helped in the development of his ideas by Oxford botanists. In 1736 Linnaeus visited the Sherardian Professor of Botany, Dillenius, and after an initial misunderstanding, appropriately enough over language, they became friends. Linnaeus was to cite his indebtedness to Dillenius in his *Species plantarum*, and also used the pioneering work in plant classification from Morison's *Plantarum historiae*.

A much earlier solution to the problem of different names for the same plant had been the introduction of botanical illustrations in herbals and treatises. This had been made possible *c.* AD 100, when a technical change in the production of paper resulted in long rolls of papyrus being replaced by

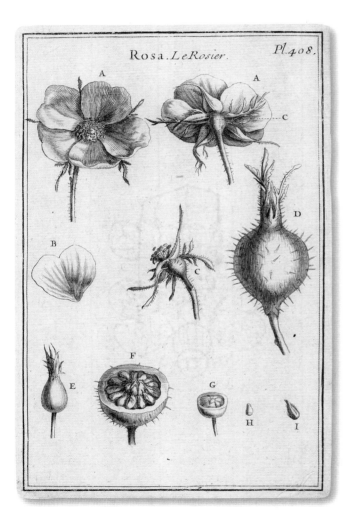

Rosa. LeRosier. Pl. 408.

papyrus in sheets, bound into volumes. Before this innovation, readers had to hold the roll in both hands and read a few lines of text at a time, and would therefore find it difficult to take in the whole of an illustration. With bound volumes, artists could produce an illustration of a plant that was integrated with the textual description. The first illustrators may have drawn their pictures with live plants in front of them, but as treatises on plants such as Dioscorides' *De materia medica* were copied out again and again, the gap between the plant and reality grew ever greater. The painting of the lily and other herbal plants from the eleventh-century version of the medical treatise

In his *Elemens de botanique* published in 1694, the French botanist Joseph Pitton de Tournefort set out his system of plant classification according to the form of the flower. On this page, he shows the Dog Rose, *Rosa canina*, with its very particular arrangement of sepals.
PS: *Elemens de botanique*, plate 408 (Sherard 673)

of Apuleius (p. 22) shows this all too clearly. Only with a completely new treatise, *Tractatus de herbis*, produced *c*.1300 by Albertus Magnus, Bishop of Regensberg in Germany, was there the beginning of the development of the depiction of plants in a clear and straightforward manner.

With the invention of printing, herbals and botanical books became available to a much larger public. An early printed German herbal was compiled by Otto Brunfels, a Carthusian monk physician turned Lutheran schoolmaster, who published his *Herbarum vivae eicones* in Strasbourg in 1530. In the spirit of the Reformation, he was keen to bring accuracy to pharmacy and to prevent scams that were both expensive and dangerous for patients. While Brunfels used yet again the texts of the botanists of the classical world, Theophrastus and Dioscorides, the accompanying images were of a quite different order. These were produced by Hans Weiditz, who had been taught by the great German artist, Albrecht Dürer. His teacher had advised 'Be guided by nature . . . Do not depart from it, thinking that you can do better yourself. You will be misguided, for truly art is hidden in nature and he who can draw it out, possesses it.' Dürer produced a whole series of watercolours of plants that still astonish us with their beauty and acute observation. Perhaps the most remarkable, *Das grosse Rasenstück*, is a worm's eye view of a piece of meadow turf with blades of grass and dandelion flowers. Weiditz's illustrations, such as the narcissus with a snowflake (p. 49), had to contend with the restriction on space when they were turned into woodcuts made from fruitwood, so the artist was obliged to concentrate on the vital parts. It was no doubt the skill of Weiditz that made Brunfels' book into a bestseller throughout Europe.

One way of bringing more detail into these black-and-white illustrations was to have them coloured, as seen in the violas from Pierandrea Mattioli's 1558 *Commentarii* (p. 146). Until colour printing was

developed in the nineteenth century, this was the only way of providing colour illustrations, and publishers employed hand colourists, often women and children, to do this work. They, like many of the artists and engravers, are anonymous, so are commemorated here by a most unusual sight, the portraits that appear at the end of *De historia stirpium*, by Leonhart Fuchs, published in Basle in 1542.

In writing the book, I have had invaluable help from Dr Stephen Harris, Druce Curator of the Oxford University Herbaria: his knowledge of botany and of all manner of subjects beyond is masterly. His colleague Anne Marie Townsend undertook the task of researching the pictures, drawing on her unrivalled knowledge of the contents of the Plant Sciences Library. I am also grateful to Serena Marner, with her acute observations of the Plant Sciences Collection, to Theo Dunnet and Marija Babic at the Radcliffe Sciences Library, and to Louise Allen at the University Botanic Garden. Thanks also to Patricia Williams, Professor Jonathan Dancy, and Liz Morrison.

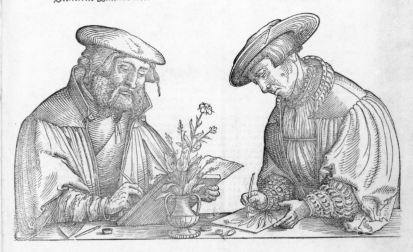

PICTORES OPERIS,
Heinricus Füllmaurer. Albertus Meyer.

SCVLPTOR
Vitus Rodolph. Speckle.

Leonhart Fuchs acknowledged the contribution made by his artists and engravers in *De historia stirpium*, Basle, 1542. Here are shown the artist, Albrecht Meyer, making his drawing of a corncockle from life, alongside Heinrich Füllmaurer, who is transferring an illustration to a woodblock, and below, the engraver, Veit Rudolf Speckle.

PS: *De historia stirpium* (Sherard 646)

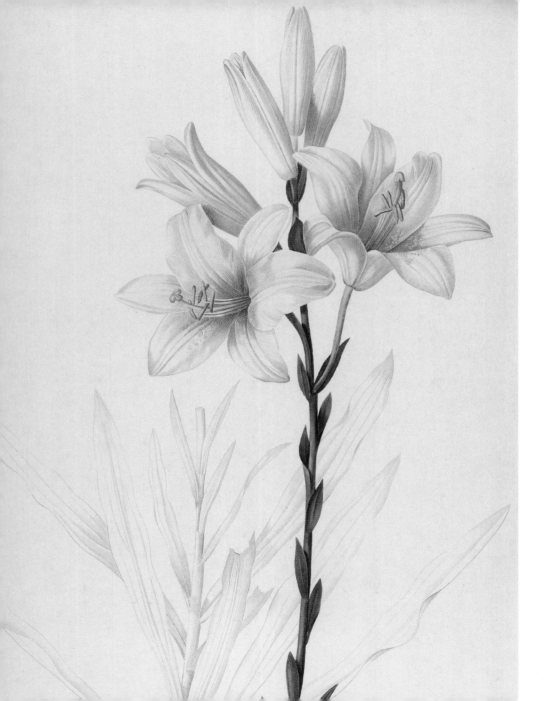

Pierre-Joseph Redouté is most familiarly associated with the rose (p.143), but he also produced a huge work on the lily and lily-like plants, *Les Liliacées*, produced in eight folio volumes between 1802 and 1816. Many of the plants that he featured are no longer classified as lilies, including the banana, *Musa paradisaica*, but he was on sure ground with the *Lilium candidum* shown here.

RSL: *Les Liliacées*, vol. 5, opp. p.199 (RR.y.iii(v))

The Lily

The white lily, *Lilium candidum*, is thought to have been introduced into Britain by Roman soldiers in their kitbags. The bulb could be stewed and eaten, but as Henry Lyte explained in his herbal, published in 1578, the whole plant also had medical uses: quoting the Roman naturalist Pliny he recommended the bulb cooked in water and honey to lay siege to 'all corruption of the blood', to heal ulcers, tumours, and to ease dislocated limbs, and when boiled in vinegar to relieve corns. The leaves and seeds were both good for coping with snake-bites. No wonder the Romans carried the white lily on their campaigns.

In the Middle Ages, the lily took on a much more revered role with its association with the Virgin Mary: indeed, *L.candidum* later came to be known as the Madonna Lily to distinguish it from other white lilies. It featured in Annunciation scenes, sometimes with the Angel Gabriel holding a stem of lilies, sometimes with a pot of lilies in the foreground. This association was not surprising, for the white lily represented beauty, purity, and serenity, with a wonderfully sweet smell: in other words, perfection. This was summed up by William Shakespeare in the fourth act of *King John*, written in 1596:

> To gild refined gold, to paint the lily . . .
> Is wasteful and ridiculous excess.

A study by Hans Memling of a single stem of a white lily along with purple irises and columbine, painted *c.*1485 and now in the Museo Thyssen-Bornemisza in Madrid, has been described as the first flower-piece. The early illustrations in sixteenth-century botanical books do not show *L.candidum* to advantage because of the limitations imposed by the shape and size of the woodblock. But another

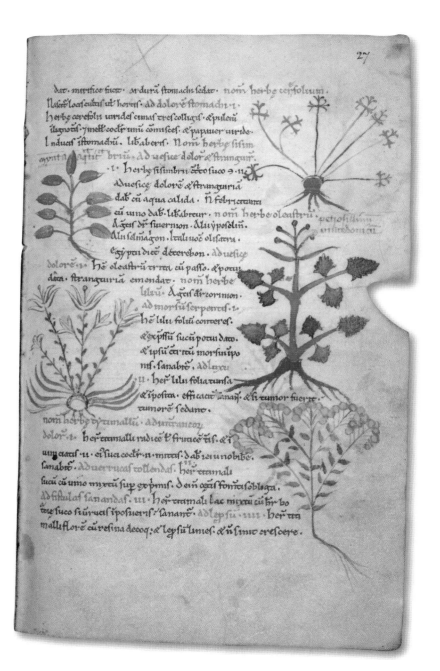

The lily featured in early medieval herbals because of its healing properties. In this version of the medical and culinary treatise by Apuleius, written and illustrated in the eleventh century by the monks of St Augustine's Abbey in Canterbury, the lily is shown below left, along with other herbs.

Pseudo Apuleius Herbal, Bodleian Ms.Ashmole 1431, fol.27r

kind of lily looked very effective in this form of print: the Martagon or Turkscap. It does indeed resemble a Turk in his turban, far more so than the tulip – which took its name from the Turkish for turban through a verbal misunderstanding. The Purple Martagon (*L.martagon*) is said to have come to Western Europe in the 1590s, though another school of thought dates its arrival much earlier, brought back in the bags of the Crusaders. The Scarlet Turkscap, *L.chalcedonicum*, was one of several exotic flowers from Turkey that was planted in the Botanic Garden in Vienna, and later in Leiden by Charles de L'Ecluse, or Clusius. Whether the Turkscap featured on the title page of his *Rariorum plantarum historia*, published in 1601 (p. 91), is the Scarlet or the Common Turkscap is scarcely important now: it is the excitement engendered by such new arrivals that can still be sensed.

If the Middle Ages saw the Madonna Lily as one of the pre-eminent flowers, it is natural that it should enjoy a second florescence in the nineteenth century with the Pre-Raphaelites. Once more the lily was shown in Annunciation scenes, but also, given the Victorian obsession with death, it starred at funerals and was tinged with decadence through its association with the Aesthetes. Oscar Wilde went up to Magdalen College, Oxford, in October 1874 and began what he described as 'the most flower-like time' of his life. He took great interest in the furnishing of his college rooms, buying blue-and-white china from Spier's Emporium in the High Street to contain his arrangements of Madonna Lilies. 'I find it harder and harder every day to live up to my blue china,' was probably the first of his throwaway lines that was to bring him notoriety and ultimately destruction. W. S. Gilbert mocked the pretensions of Oscar Wilde and the Aesthetes in *Patience*:

> Though the Philistines may jostle, you will rank as an apostle in the high aesthetic band,
> If you walk down Piccadilly with a poppy or a lily in your medieval hand.

The Aesthetes also greeted with joy the arrival of the spectacular lilies from Japan, opened up to the West in the 1860s. The Golden-rayed Lily, *L.auratum,* was introduced to Britain in 1862, followed at the end of the century by *L.henryi* and *L.regale* from China. These were displayed in oriental porcelain or in long glass lily vases that showed off their elegance. The history of the discovery of the various exotic species of lilies reflects the history of European explorers: first, the Middle East, then the Americas in the seventeenth and eighteenth centuries, followed by the Himalayas and the Far East. William Goldring in *The Book of the Lily,* 1905, recorded:

> We owe much to the men of the last century, to those especially who, in the early 'forties and 'fifties down to the present time, explored the wilds of California, or the garden treasures of Japan, which had existed unknown to Western peoples, probably for centuries. These men, at the risk of their health and often their lives, did their utmost to enrich our gardens with the flower treasures of other countries.

The plant hunter Ernest Wilson would endorse this, for in his search for the *L.regale* on an expedition to the borders of China and Tibet in 1910, he broke his leg trying to escape a landslide, and the subsequent infection nearly killed him; he referred thereafter to his 'lily limp'.

The wonderful range of lilies available to British gardeners can be seen in the *Monograph of the Genus Lilium* compiled by Henry John Elwes in 1880 with the help of J. G. Baker, keeper of the herbarium and library at Kew. Elwes was a natural historian with wide interests: he began as an ornithologist but became adept at growing new and rare plants, several of which are named after him. Perhaps the best known is not a lily, but a snowdrop, *Galanthus elwesii,* which he gathered near Smyrna in Turkey in 1874.

...ngraving of *Lilium chalcedonicum*, ...he Scarlet Turkscap, with *Lilium* ...*andidum* and a lily bulb showing its ...haracteristic scaly covering, from the ...*Hortus Eystettensis* compiled by Basil ...esler and published in 1613. Besler ...as a Nuremberg apothecary who ...njoyed the patronage of the Prince-...ishop of Eichstatt, a keen lover of ...owers and creator of a wonderful ...arden around his residence, the ...Vilibaldsburg. Work on the drawings ...ook sixteen years, with a team of six ...etal engravers for the 374 plates that ...lustrated more than 1,000 flowers. ...t is arranged by seasons, no doubt ...ecause chests of fresh specimens ...ere sent weekly during their ...owering period from Eichstatt to ...Juremberg. The resulting two parts ...ere sometimes bound in one volume ...hat proved so huge and heavy that a ...heelbarrow was reputedly required ...o transport it.

S: *Hortus Eystettensis*, Quintus Ordo fol. 8v
Sherard 618)

Lilium Byzantinum flore multi-plici

Lilium album.

Scapus Lily.

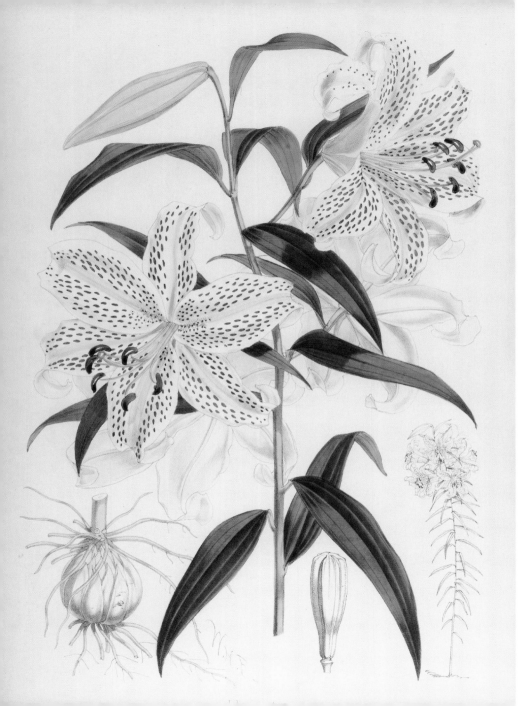

Oriental lilies from the *Monograph of t* *Genus Lilium* by H. J. Elwes, published in 1880. Right: the Tiger Lily, *Lilium tigrinum* was probably introduced to Europe from China in 1804 by Capt. Kirkpatrick, master of an East India Company ship. Elwes noted that this specimen, 'var. fortunei', which flowe in a pot in his garden in August 1876 was an old Chinese variety named af Robert Fortune, the plant hunter. Le the Golden-rayed Lily, *Lilium auratum* caused a sensation when it arrived in Western Europe from Japan in the early 1860s. The German botanist, Philipp Franz von Siebold had tried to introduce it in 1829, but it died on the journey, and it was only with the combination of the opening up of Yokohama to European commerce and the developing technology in transporting plants that the lily's safe conveyance was possible.

PS: *Monograph of the Genus Lilium*, tabs 38,30

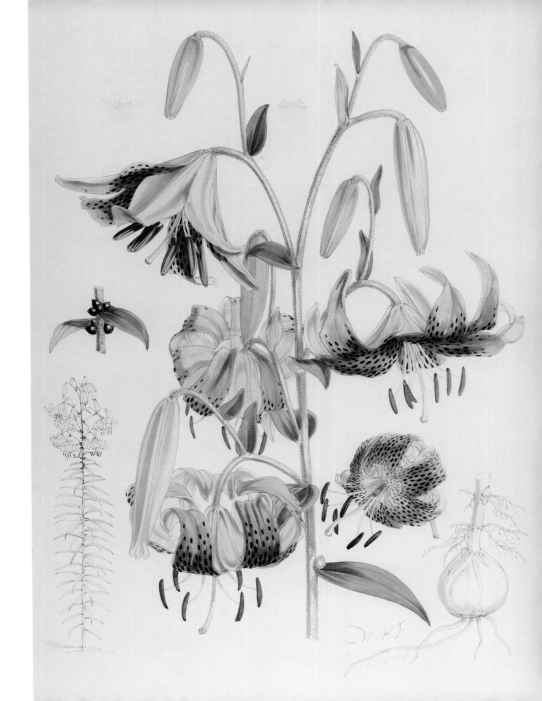

Gertrude Jekyll was a great admirer of the flower and wrote *Lilies for English Gardens*, subtitled 'A Guide for Amateurs', first published in 1901. She recommended the Madonna Lily with its long slender stems for cottage gardens; for moisture-loving lilies, such as *L.giganteum* (now known as *Cardiocrinum giganteum*) and *L.auratum*, she advised a woodland setting. Some of her ideas are to be seen at Barrington Court in Somerset. Jekyll was in her late seventies when she was consulted by the architect laying out the gardens there shortly after the First World War. Although she was almost blind, she was able to analyse the limy soil sent in biscuit tins by crumbling the earth in her fingers, and plans were duly hatched for the various walled areas, including a lily garden. In her book, she had warned that white, pink, and lemon lilies were best not combined with other flowers but should be displayed in separate groups with quiet greenery. Scarlet and orange flowers, on the other hand, could succeed in mixed borders and would do well in rhododendron or azalea beds, where the young growth could be protected.

The Lily Garden at Barrington, recently restored by the National Trust, shows a brilliant palette using lilaceous flowers such as crocosmia, day lilies, alstroemarias, cannas, and crinums in combination with azaleas, dahlias, heleniums, and rudbeckia. Ironically almost all the 'lilies' chosen by Jekyll for the garden are no longer described as such, following a reclassification of the Liliaceae family in the 1990s.

In the Middle Ages gardeners had only the white lily, and possibly the Purple Martagon for their cultivation, but early illustrations show how they loved them, proudly displaying them in pots. Despite the recent botanical reorganization, we have a huge range of lilies to choose from, and they are still beloved, coming second only to the rose in a recent poll of favourite flowers.

MARK CATESBY

Red Lily and a Wampum snake from the second edition of Mark Catesby's *Natural History of Carolina, Florida and the Bahama Islands*, published in 1754. Catesby first went to Virginia in 1712 and spent the next seven years travelling there and in the Carolinas and the Bahamas. The unrivalled collection of dried plants that he brought back to England prompted William Sherard, Sir Hans Sloane, and other members of the Royal Society to support his return to North America in 1722. Basing himself in Charleston, he again collected plants from the east coast, sending back specimens to Sloane and Sherard, and to Thomas Fairchild, the Hoxton nurseryman. When preparing his pioneering publication, Catesby taught himself how to engrave from his own illustrations.

The Wampum snake probably got its name from the similarity between its colouring and chain-like pattern and the shells used by the Indians as currency.

Catesby described the Red Lily, which was later to be named *L.catesbaei* after him, as growing 'from a single bulbous scaly Root about the Size of a Walnut, rising with a single Stalk to the Height of about two Feet . . . the whole Flower is variously shaded with Red, Orange and Lemmon Colours. They grow on open moist *Savannas* in many Parts of *Carolina*.' Specimens of this lily, sent by Catesby, are preserved in the Sherard Herbarium in Oxford.

PS: *Natural History of Carolina, Florida and the Bahamas*, tab 58

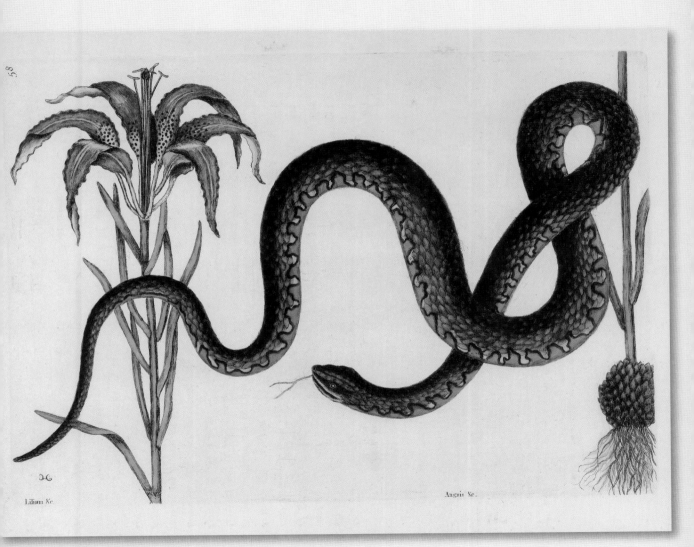

Lilium &c.

Anguis &c.

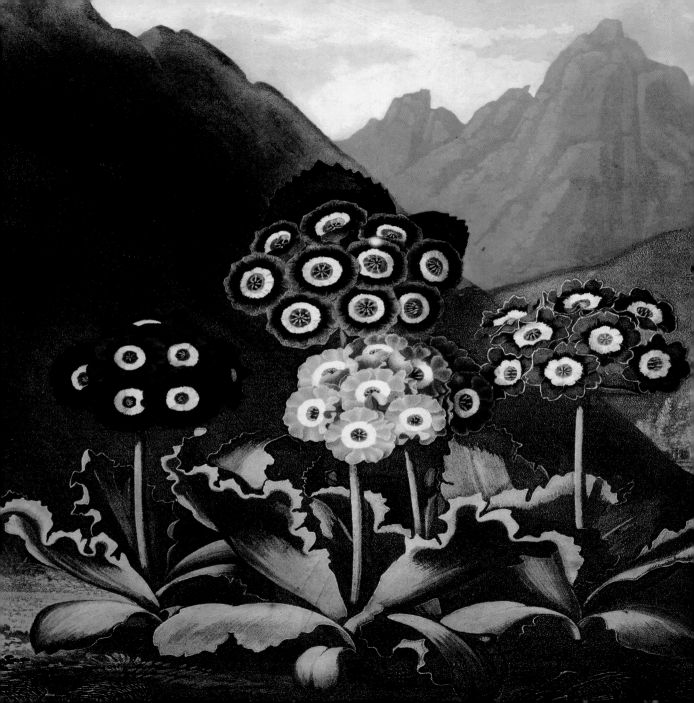

The Auricula

Carolus Clusius first came upon yellow auriculas while exploring the woods near Vienna. Clusius, or Charles de L'Ecluse, was a doctor from Arras in Flanders, who was appointed prefect of the imperial medical garden in Vienna in 1573 by the Habsburg Emperor, Maximilian II. Noting that this Alpine member of the primula family had leaves shaped like bears' ears, he called it *Auricula ursi* and it is familiarly known as Bears' Ears, and sometimes as Dusty Miller from the fine powder to be found on both the leaves and the flowers. Clusius made mention of auriculas in the 1583 edition of his book, *Rariorum plantarum historia*.

Clusius left Vienna in the late 1570s, making his home first in Frankfurt am Main, and then in Leiden. Here he was appointed professor in 1593 and established the University's formal Botanic Garden, in which among many plants he cultivated auriculas. Tradition has it that Huguenot refugees, fleeing religious persecution in France, introduced the flowers into England. John Gerard called them mountain cowslips in his herbal in 1597 and explained how people living in the Alps used the roots as a cure for giddiness while climbing. He also noted how they flourished in London gardens, assuring their popularity among all levels of gardening society.

Robert John Thornton was a London physician who decided to produce a tribute to Linnaeus. His project, *New Illustration of the Sexual System of Carolus von Linnaeus*, published in 1807, was extremely ambitious, large in format, and grandiloquent in language, and, despite efforts to make it work financially, such as a lottery, the publication eventually bankrupted him. Included with the text on Linnaeus was a 'Temple of Flora', coloured engravings that Thornton described as 'Picturesque Botanical Plates', with what he felt were appropriate backgrounds for the flowers. In this example, a group of auriculas is set against the Alps, where Clusius first came upon the flowers in the sixteenth century. Left to right: 'Redman's Metropolitan', 'Egyptian' (below), 'Cockups Eclipse' (above), 'Grimes' Privateer'.

PS: *Temple of Flora*

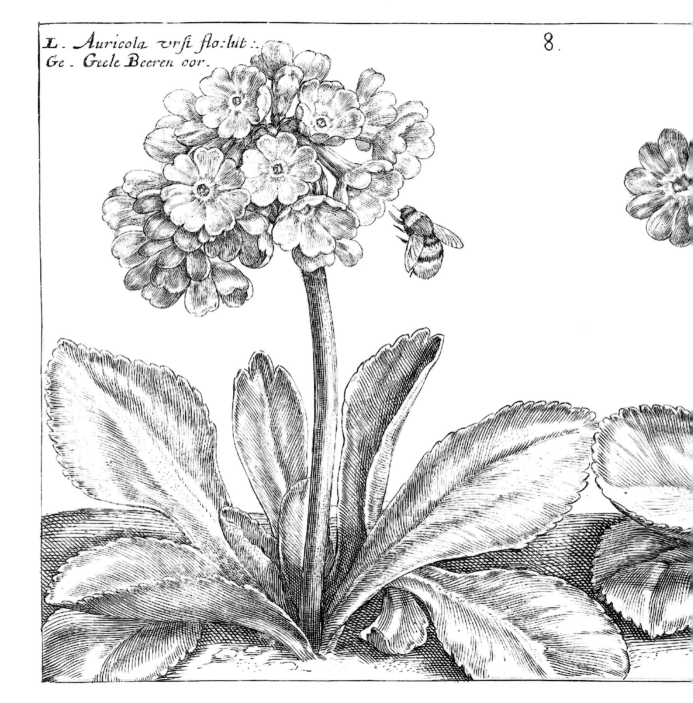

L. *Auricola ursi flo:lut:.*
Ge. *Geele Beeren oor.*

8.

L. *Auricola vrsi flore violaceo.*
Ge. *Beeren ohr violbraun.*

The Sun King Louis XIV, no less, was a fan. Perhaps he appreciated their spiritual dimension, for an anonymous French writer described auriculas as a source of religious satisfaction, inviting the grower to lead a saintly life free from reproach. John Rea was a member of a group of British horticulturalists in the mid-seventeenth century that included Sir Thomas Hanmer, John Evelyn, and John Rose, Charles II's gardener. Rea's garden was at Kinlet

Auriculas in *Hortus Floridus*, from the first edition published by the de Passe family in 1614 in Arnhem. Most of the plates were engraved by the very talented Crispijn, then aged 20, helped by his younger brothers. Their father, also Crispijn, organized the preparation of the text, production of the plates, printing, and distribution. This was a complex venture, for the first edition was published in Latin with Dutch labels added to the pictures, while subsequent editions added French, English, and occasionally Italian names to reach an international market. The auriculas are shown in spring, their season of flowering, and are highly naturalistic, with perspective detail giving the viewer the impression of being in an actual garden.

Hortus Floridus, tab 8, Bodleian Vet.B2.c.1

in Shropshire, and here he not only cultivated his flowers but also wrote about them. In 1665 he published *Flora, Ceres and Pomona*, in which he described auriculas as 'nobler kinds of <u>cowslips</u> and now much esteemed in respect of the many excellent varieties thereof of late years discovered differing in size, fashion and colours of the green leaves'. He then lists the different kinds 'as may be sufficient to stock a <u>Florists Garden</u>' under various colours. 'Mistris Buggs her fine purple,' he explains, was raised by the widow of the London nurseryman John Buggs in her garden at Battersea. This auricula is one of those preserved in the Bobarts' herbaria (see p. 42). From Oxford comes another purple, named after Mr Good of Baliol College, and several red and scarlet auriculas raised by 'Mr Jacob Bobart, keeper of the publique garden'. It was John Rea's son-in-law, the botanist Samuel Gilbert, who nominated the auricula as a florist flower.

The modern use of the term 'florist', meaning a retailer of cut flowers, dates from the 1870s. Two hundred years earlier it was applied to the horticultural equivalent of bird-fanciers, people who developed and exhibited pot-grown plants. Originally florists' flowers were the carnation, tulip, anemone, and ranunculus, joined in the late seventeenth century by the auricula. The enthusiasts were town-based, forming themselves into societies. In Holland and the Low Countries the societies had religious affiliations and were often dedicated to St Dorothy, the patron of flower lovers. The society in Bruges, for instance, had eighteen members, wealthy landowners and high-ranking clergymen, who met on St Dorothy's Day, 6 February, to celebrate Mass and hold a banquet. In the seventeenth century these societies were for tulip lovers, but by the eighteenth, auriculas had become the centre of attention. A book in the Bibliothèque Royale in Brussels, *Nouveau traité de la culture parfaite des oreilles d'ours ou auricules*, published in 1738 and probably by the Abbé of Amiens, describes these societies and their connection with the Church. Referring to 'curieux fleuristes', he noted that they had created *confréries* or brotherhoods in several towns, where they met once a year to talk and examine the latest creations, which were divided into three groups: Pures, Bizarres, and Panachées.

In England, florist societies were secular in style and activities, particularly enjoying their feasts. A play written by Ralph Knevet, *Rhodon and Iris*, performed at such an event of the Norwich Florist Society held on 3 May 1631, has survived in printed form in the Bodleian Library. The preface refers to a feast 'celebrated by such a conflux of Gentlemen of birth and quality in whose presence and commerce (I thinke) your cities welfare partly consists', suggesting that merchants were among the members. Two poems, also in the Bodleian, are connected with the Norwich feast, and refer to carousing with cups of beer (see p. 107). Although the feast was in honour of Flora, William Strode, the author of one of the poems, denies that this shows pagan tendencies, rebutting the disapproval of local Puritans.

References to florists' feasts are mentioned for towns right across England, from Canterbury to Gloucester, from Ipswich to Newcastle upon Tyne. Our knowledge is very much based on notices in eighteenth-century newspapers. Thus the *Craftsman* for 16 April 1729 records:

> On Tuesday last a great Feast of Gardiners was held in the Dog in Richmond Hill, at which were present about 130 in Number; after Dinner several shew'd their Flowrs (most of them Auricula's) and five ancient and judicious Gardiners were Judges to determine whose flowers excelled . . . a Gardiner of Barnes in Surrey was so well furnished with good Flowers, that the Judge in the affair ordered him two Spoons [silver spoons were often the prize] and one Ladle.

The usual venue for such activities was a public house, with the flowers given to stewards by midday. Dinner was served at 1 p.m. and then the flowers, having been judged, were passed round the table, either in pots or cut.

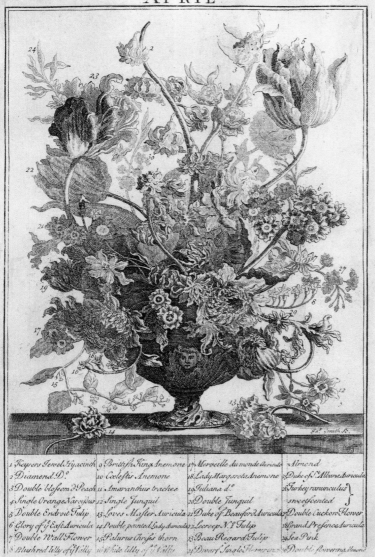

APRIL

1 Keysers Jewel Hyacinth	9 Brittish King Anemone	17 Merveille du monde Auricula	Almond
2 Diamend D.º	10 Cœlestis Anemone	18 Lady Margareta Anemone	25 Duke of S.ᵗ Albans Auricula
3 Double blossom'd Peach	11 Amaranthus trachee	19 Iuliana d.º	26 Turkey ranunculus
4 Single Orange Narcissus	12 Single Iunquil	20 Double Iunquil	sweetscented
5 Double Endroit Tulip	13 Loves Master Auricula	21 Duke of Beauford Auricula	Double Cuckow Flower
6 Glory of y.ᵉ East Auricula	14 Double painted Lady Auricula	22 Leoresp. N.ᵗ Tulip	28 Grand Presence Auricula
7 Double Wall Flower	15 Palurus Chrissethorn	23 Beau Regard Tulip	29 Sea Pink
8 Blush red lilly of y.ᵉ Valley	16 White lilly of y.ᵉ Valley	24 Dwarf Single Flowers	30 Double flowering Almond

'April' from Robert Furber's *Flower Garden Display'd*, 1732. Seven varieties of auriculas are shown, including a 'double painted lady', together with hyacinths, narcissi, jonquils, and two tulips.

Flower Garden Display'd, Bodleian Don.d.144

The florists' year can be traced by the activities of the Ancient Society of York, formed in 1768 and still going, with its records preserved in the central library. A feast was held on the day of the auricula show in the spring, where polyanthus and hyacinths were also exhibited. The tulip show was held in May, sometimes with anemones; in June came the turn of ranunculus, with carnations in August. Tradesmen made up most of the membership, especially apothecaries.

George Crabbe in his poem *The Borough*, written in 1810, describes the excitement of a florist winning the prize for auriculas, and also the reasons why these flowers lent themselves so well to such competitions:

> These brilliant hues are all distinct and clean,
> No kindred tints, no blending streaks between,
> This is no shaded, run-off, pin-eyed thing:
> A king of flowers, a flower for England's king.

The fashion in auriculas in the seventeenth and early eighteenth centuries was for double-flowered and striped forms. A red-flowered variety, known as polyanthus, appeared in the 1680s, and gold-laced forms were developed from this. Many of the most favoured blooms, often with wonderfully evocative names, have disappeared, but some can be found, albeit in faded form, in the herbarium of Jacob Bobart the Elder. Others feature in the trade catalogues of nurserymen, as shown in Robert Furber's 'Twelve Months' series of illustrations. Furber first produced his *Flower Garden Display'd* in 1732 to depict the flowers available at his nursery in Kensington Gore in London, and, as he explained on his title page, 'very useful for the Curious in Gardening'. He and his fellow nurserymen were also supplying auriculas to city households for display in decorative ceramic pots, as recommended in 1728 by Batty Langley in his *New Principles of Gardening*.

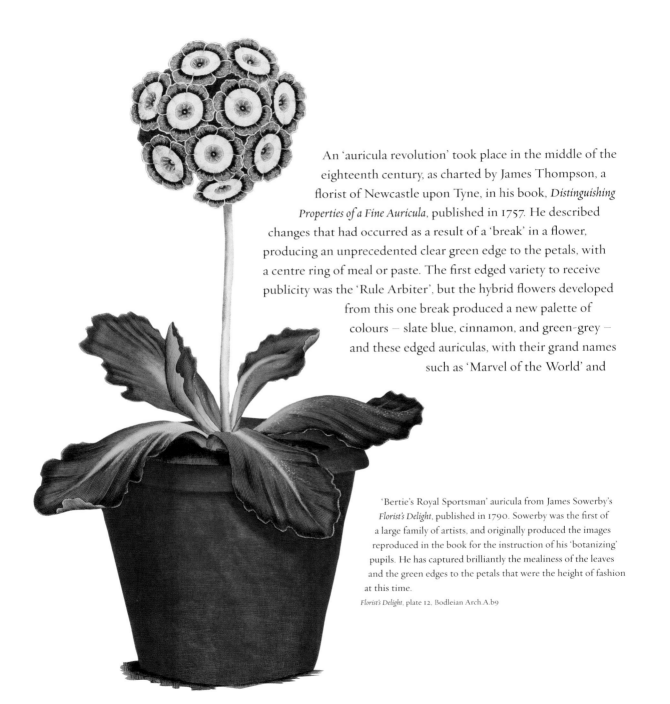

An 'auricula revolution' took place in the middle of the eighteenth century, as charted by James Thompson, a florist of Newcastle upon Tyne, in his book, *Distinguishing Properties of a Fine Auricula*, published in 1757. He described changes that had occurred as a result of a 'break' in a flower, producing an unprecedented clear green edge to the petals, with a centre ring of meal or paste. The first edged variety to receive publicity was the 'Rule Arbiter', but the hybrid flowers developed from this one break produced a new palette of colours – slate blue, cinnamon, and green-grey – and these edged auriculas, with their grand names such as 'Marvel of the World' and

'Bertie's Royal Sportsman' auricula from James Sowerby's *Florist's Delight*, published in 1790. Sowerby was the first of a large family of artists, and originally produced the images reproduced in the book for the instruction of his 'botanizing' pupils. He has captured brilliantly the mealiness of the leaves and the green edges to the petals that were the height of fashion at this time.

Florist's Delight, plate 12, Bodleian Arch.A.b9

'Glory of the East', became fashionable. This taste was not shared by European gardeners, who called the edged flowers 'English auriculas', preferring petals of solid colour, known as 'shaded' or 'alpine'.

Whether edged, shaded, or alpine, such theatrical flowers deserve appropriate surroundings, and so were displayed on staged stands known as auricula theatres. One such is illustrated in *Nouveau traité* of 1738 mentioned above, where the author stipulates that the theatre should open to the north, and have a roof that protects the plants from the rain but gives them plenty of fresh air. He suggests painting the backdrop of the theatre with perspective decoration so that it looks good even when there are no flowers on display. Such a theatre has survived in a corner of one of the walled gardens at Calke Abbey in Derbyshire. Probably built in the 1770s, it has been restored by the National Trust with blue shelves to set off the brilliant colours of the auriculas and their grey-green leaves. A display is mounted each year between mid-April and the end of May by local growers, maintaining the proud florists' tradition.

JACOB BOBART, FATHER AND SON

The Bobarts played a major role in the development of botany at Oxford. The elder, born in Brunswick *c.*1599, became a soldier before settling in Oxford, possibly as an innkeeper, possibly as a tea-merchant. In 1642, shortly before the outbreak of the English Civil War, he became superintendent of the Botanic Garden that had recently been founded by the Earl of Danby. Because of the war, Danby's estates were sequestrated and Bobart received no salary for the position, but luckily whichever part of the catering trade he had followed gave him sufficient income on which to live. Jacob Bobart the Elder combined eccentricity – he tagged his waist-long beard with silver on high days and holidays, and was accompanied around the garden by his pet goat – with a strong character, which enabled him to cope with the university dons.

He began a herbarium of pressed flowers, a *hortus siccus* that showed the plants growing in the Botanic Garden, and this remarkable record was continued by his son, born in Oxford in 1641. A much less flamboyant character than his father, the younger Jacob was scholarly by inclination, filling twelve folio volumes of the herbarium with some 2,000 named specimens. On his father's death in 1680, he became superintendent of the Garden and took over the University's lectures on botany at the untimely death of the professor, Robert Morison. He also had to take over the editing of Morison's *Plantarum historiae universalis Oxoniensis*, a huge undertaking that involved thirteen years of writing and research. At the same time he was adding to the collections in the Botanic Garden by exchanging seeds, plants, and dried specimens with a range of fellow botanists.

The Bobarts' herbaria are treasures of the Plant Sciences Department of the University, containing specimens of vanished cultivars. In the 1648 list of plants grown in the Botanic Garden the auriculas are classified according to colour, 'Beares eare white', 'Brimstone colour'd Beares eare', and so on. But in Bobart the Elder's

herbarium were applied wonderful names such as 'Bugs Purple and Yellow', 'Plumpton Duchess of Cleveland', 'Flourishing Prince', 'Fair Hanna', and 'Roses Morning Star'. This page comes from the collection of Bobart the Younger, with his caption recording that the auriculas pressed here are striped, prized forms of the period.

PS: Bobart the Younger's *hortus siccus*, 234

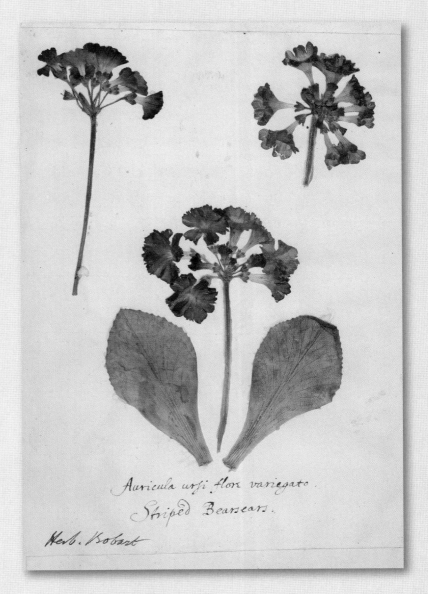

Auricula ursi flore variegato.
Striped Bearsears.

Herb. Bobart

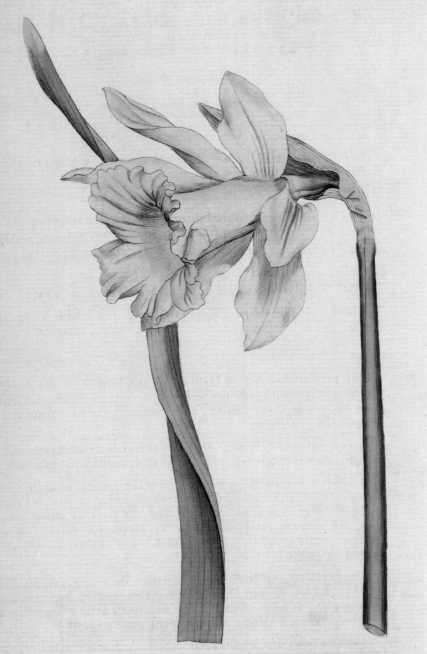

Publish'd by W. Curtis, Botanic Garden Lambeth Marsh.

Like the snowdrop and the fritillary, there is some debate as to whether the daffodil, *Narcissus pseudonarcissus*, is native to Britain. Whatever the case, it flourishes. So prolific was the daffodil in Tudor times that Clusius reported how Cheapside turned golden in spring with huge numbers of bunches picked from the outskirts of London and brought in for sale on market stalls. This illustration of the daffodil is taken from Curtis's *Botanical Magazine*, see p.55.

The Daffodil and the Narcissus

The name narcissus is derived from the Greek legend made famous by Ovid in his *Metamorphoses*. Narcissus, the beautiful son of the river god and a water nymph, fell in love with his reflected image and wasted away till death, leaving only a flower, 'white petals clustered round a cup of gold'. This connection is echoed in the elaborate language of flowers contrived by the Victorians, where the narcissus and daffodil represented selfishness and egotism. Just to add to the gloom and doom, they also have funerary connotations. According to a Homeric hymn, the narcissus was created by Earth at the behest of Zeus to please Hades, and the Greek noun *narkissos* has the same root as the verb *narkao*, to grow stiff, from which narcotic is derived. The name daffodil can be traced back to *affodilus* in medieval Latin and *asphodelus* in Greek: the asphodel was the plant grown across meadows of the underworld belonging to Persephone. This may explain why narcissi and daffodils were both often planted on graves in the nineteenth century.

The narcissus familiar to the Greeks was *Narcissus tazetta*, native to the Mediterranean: it is often known as Bunch-flowered Narcissus. In 1573 the Bavarian physician Leonhard Rauwolff set out on an epic three-year journey from Augsburg to Tripoli, Aleppo, Baghdad, and Jerusalem to confirm the qualities of herbs that had been described by physicians of the ancient world. Despite being constantly on the road, he managed to compile a herbarium, which is now at Leiden. In Aleppo he saw narcissi, including the double variety: 'In their gardens the Turks love to raise all sorts of flowers, in which they take great delight and put them in their turbans, so I could see the fine plants one after another daily, without trouble.' A consignment of bulbed plants sent to William Cecil, Lord Burghley, included what Gerard described in his herbal of 1597 as 'double white daffodil of Constantinople'. From Spain and Portugal came the *N.jonquila*, with its sweet scent and graceful form, and from Southern Europe *N.poeticus,* the Pheasant's Eye or Poet's Narcissus.

The British, however, had the daffodil, *N.pseudonarcissus*, so called because *N.poeticus* was considered the only 'true' form. The daffodil was given many local names, including Butter and Eggs in the south-west of England and in Northamptonshire, and its flowering time resulted in names such as Lent Lily, Lent-Cocks, Lent Pitchers, Lent-Rosen and Easter Lily. It was *N.pseudonarcissus* rather than the more appropriately named *N.poeticus* that inspired the most famous literary lines on the daffodil. William and Dorothy Wordsworth were visiting the Lake District when they came upon wild daffodils on the shore of Ullswater.

The classical legend of Narcissus, which would have been familiar to readers of Ovid in the late Middle Ages, survives in this charming woodcut from the *Ortus sanitatis* published in Mainz in 1491. Although produced seven centuries after the drawing by a Byzantine artist in Dioscorides' *De materia medica*, it is crude and almost entirely divorced from botanical accuracy.
RSL: *Ortus Sanitatis* (RR.x.272)

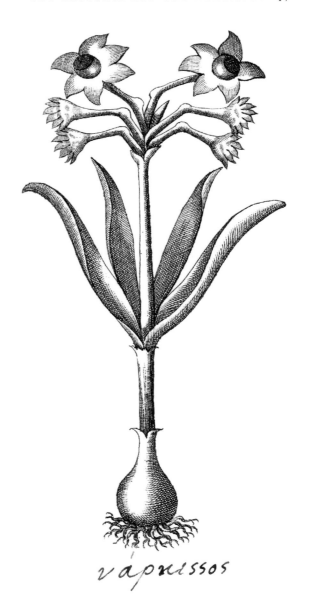

Dorothy recorded in her journal for
15 April 1802: 'When we were in the
woods beyond Gowbarrow Park we saw
a few daffodils close to the waterside. We
fancied that the lake had floated the seeds
ashore and the little colony had sprung
up.' William's contribution was the lines:

> I wandered lonely as a cloud
> That floats on high o'er vales and hills
> When all at once I saw a crowd
> A host of golden daffodils.

Drawing of *Narcissus poeticus*, traced and engraved in
the eighteenth century on copper. This was one of
the illustrations that Gerhard van Swieten, personal
physician to the Empress Maria Theresa, arranged to
have delineated from the *Codex Vindobonensis*, a seventh-
century copy of Dioscorides' *De materia medica*. He made
two copies, one of which he gave to John Sibthorp
during his stay in Vienna, and the book accompanied
Sibthorp when he set off to Greece to investigate the
plants described by Dioscorides, and to produce his *Flora
Graeca*.

PS: *De Materia medica*, f.244 (Sherard 443)

νάρκισσος

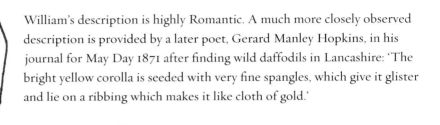

William's description is highly Romantic. A much more closely observed description is provided by a later poet, Gerard Manley Hopkins, in his journal for May Day 1871 after finding wild daffodils in Lancashire: 'The bright yellow corolla is seeded with very fine spangles, which give it glister and lie on a ribbing which makes it like cloth of gold.'

Mystery surrounds why the daffodil, along with the leek, should be the emblem of Wales. Tradition has it that Welshmen wore leeks as badges for identification in battle – either against the Saxons on the advice of St David, or as archers fighting for Henry V at Agincourt. The Welsh names for the leek and the daffodil are very similar: *cenhinen* and *cenhinen pedr* respectively, and perhaps the Victorians felt the flower was more attractive than the vegetable as an emblem to wear. There are two varieties of daffodils unique to Wales: the Welsh Daffodil, with its orange trumpet and

Woodcuts from Otto Brunfels's *Herbarum vivae eicones*, 1530. Although Brunfels is commemorated on the title page of the book, it is his illustrator, Hans Weiditz, who provided the exceptional quality of the work. Brunfels paid tribute to him at the beginning of the first volume with a verse in Latin comparing him with the famous Greek artist Apelles, and praising him for producing engravings that are indistinguishable from the real thing. Here Weiditz shows the daffodil, *Narcissus pseudonarcissus*, alongside a snowflake, using his skill to fit the two plants into the restricted space imposed by the woodblocks.

PS: *Herbarum Vivae Eicones*, p.129 (Sherard 407)

NARCISSVS.

A

B

De NARCISSO, & Hermodactylo,
Rhapsodia Vicesima.
⟨ NOMENCLATVRAE.
Græcæ, νάρκισσος, ἀντεγνὶς, βόλβος ὁ ἐμετικός, λίριον, ἄνυδρος.
Latinæ, Narcissus, Hermodactylus.
Germanicę, in Marcio, Hornungs blům. In Septembri, Zeytlöflin.
PLACITA AVTORVM de Narcisso.
Historia Narcissi, secundum D I O ₌
SCORIDEM, lib. 2.
NARCISSVS folia Porro simillima habet, tenuia, multo mi₌
nora, & angustiora: caulis uacuus, & sine folijs, supra dodrantem attolli₌
tur: flos albus in medio, intus croceus, in quibusdam purpureus: radix in
tus alba, rotunda, bulbosa: semen uelut in tunica, nigrum, longum. Pro₌
batissimum nascitur in montibus suaui odore. Cætera Porrum imitatur,
atq̨ hærbaceum uirus olet.

m

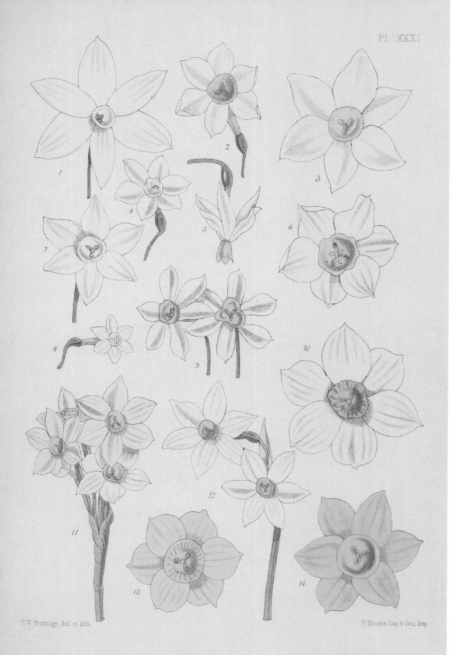

N. TAZETTA (VARS)

F.W Burbridge, del. et lith.

V. Brooks Day & Son, Imp

The Tazetta Narcissus comes in a range of forms, as shown in this page of flower heads from *The Narcissus* by F. W. Burbridge, published in 1875.

PS: *The Narcissus*, pl.xxxi

yellow petals, would appear to be native, while the Tenby Daffodil, *N.obvallaris*, is thought to be a hybrid between this and a wild daffodil from Europe. Various theories have been offered for how the Tenby variety got to Pembrokeshire, including suggesting that they came from the Phoenicians in exchange for Welsh coal, or that they were brought by medieval monks or merchants. Intriguingly, identical plants have recently been found in the mountains of Spain.

By the time that the British were colonizing North America, there were hundreds of daffodils available to introduce, and of course the bulbs were easy to transport and ideal for long sea journeys during their dormant period. Early Chinese immigrants probably introduced *N.tazetta* to the western seaboard, from which it spread across the continent. The person who appears to have sent out the first daffodils to the eastern seaboard was the Quaker merchant Peter Collinson, who from his base in London maintained a long and fruitful correspondence with the botanist and explorer John Bartram, who farmed near Philadelphia. They began to write and to exchange plants and seeds in 1733 and continued until Collinson's death in 1768; they never met, for neither travelled beyond their own country. Bartram had bought five acres on the Schuyllill River in 1728 and created the first botanic garden in North America, where he planted narcissi supplied by Collinson. In January 1739 Collinson sent over to another correspondent, John Custis of Williamsburg, 'Great Roots', which he explained were 'not the Narcis of Naples but an Autumn Narcis with a yellow crocus-like flower if I remember Right, as you'll find from the catalogue. You'll be pleased with it. Its fine shining green leaves makes a pleasant show all winter.'

As bulbs in pots, narcissi were ideal plants to decorate windowsills and the interiors of houses, providing both beauty and scent. Thomas Tusser in his *One Hundred Points of Good Husbandry* of 1557, which had expanded to *Five Hundred Points* by 1573, lists them as 'Daffadowndillies'. In the early

eighteenth century Batty Langley suggests planting jonquils in pots, surrounded by a circle of ranunculus, or wallflowers surrounded by narcissi. The Victorians were less keen on the idea of narcissi in the home, believing the scent of the flowers could induce madness: perhaps this dislike arose from the associations with death mentioned earlier.

As garden flowers they could provide a colourful meadow of colour, and this was probably the way that the narcissus specialist, Ebusuud Effendi, grand mufti of the Ottoman Sultan Süleyman the Magnificent, grew his white and yellow varieties at Karaagac near Edirne in the sixteenth century. Later, they were used in formal beds. Sir Thomas Hanmer in his Flintshire garden planted some of his beds with 'tulips, narcissus in the midst with some gillyflowers . . . and cyclamens at the four corners'. In another bed he had narcissi and jonquils, along with hyacinths, scillas, erythoniums, and 'one gray fritilary [*Fritillaria persica*]'.

These references are to narcissi rather than daffodils, which suggests that the latter were considered as wild flowers to be enjoyed in the countryside. It is difficult today to realize how ubiquitous they must once have been. In the nineteenth century trains known as 'Daffodil Specials' were put on to transport Londoners down to the West Country to see the great drifts of yellow flowers, and to buy bunches at farm gates, while thousands of cut flowers made the reverse trip to London's Covent Garden market. Daffodil breeding began in the 1830s with the work of William Herbert, Dean of Manchester, an enthusiastic and skilful hybridizer. The flowers, however, were not favourites in Victorian gardens until Peter Barr, a seedsman in Covent Garden, searched for all the varieties mentioned in 1629 by Parkinson in *Paradisi in Sole*. Barr persuaded the Royal Horticultural Society to produce a checklist of the names of daffodils available, ushering in the idea of plant registration.

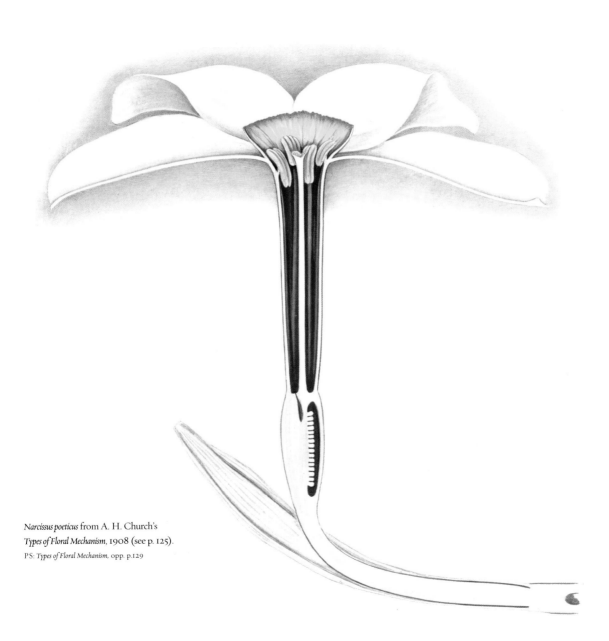

Narcissus poeticus from A. H. Church's
Types of Floral Mechanism, 1908 (see p. 125).

PS: *Types of Floral Mechanism*, opp. p.129

The growing fashion for cottage gardens initiated by William Robinson also ensured the return of the daffodil to the horticultural scene. In his *Wild Garden*, published in 1870, he described how he got good results in his garden at Gravetye in Sussex with 'the great group of forms of the common English, Irish and Scotch daffodils'. One of his illustrations shows a portion of a field with *N. poeticus*, in which he noted how easy they were to grow: no preparation of the soil was required beyond turning the sod, placing the bulbs below, and standing on the turf. The ideal plant for the modern gardener.

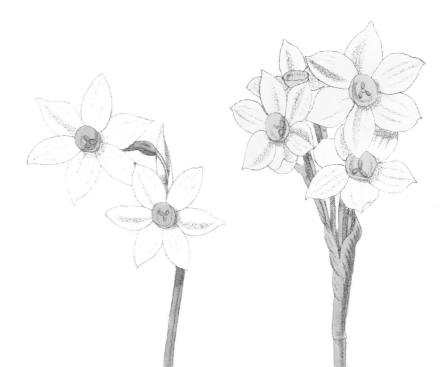

WILLIAM CURTIS

William Curtis trained as an apothecary, but his interest in botany led to his appointment as Praefectus Horti and Demonstrator of Plants at the Chelsea Physic Garden from 1772 to 1777. At the same time he established a botanic garden for the study of British native plants in Lambeth and later, to avoid smoke pollution, at Brompton, north of the Thames. He also began to work on his *Flora Londinensis*, a project that took him over twenty years, in which he concentrated on native plants within a radius of ten miles of London, though the notes of where they might be seen extended to all parts of the British Isles. He commissioned some of the finest images of British plants ever published (see pp. 73, 119 and 157). However, this was not a commercial success, partly because of the cost of illustrations, produced as 'fascicles' or groups of six plates, for which he charged 2s. 6d. plain, 5s. coloured.

See right, the daffodil, *N.pseudonarcissus*, from volume 24 of *Curtis's Botanical Magazine*, 1806. Having learnt his lesson with *Flora Londinensis*, when Curtis began to publish the magazine the price of an issue of three plates was kept at 1s.,

and the enterprise proved a great success. While many others who tried similar schemes fell by the wayside, *Curtis's Botanical Magazine* is, remarkably, still going strong.

PS: *Curtis's Botanical Magazine*, vols. 1-3, tab 51

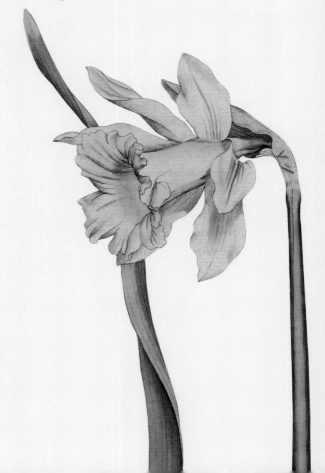

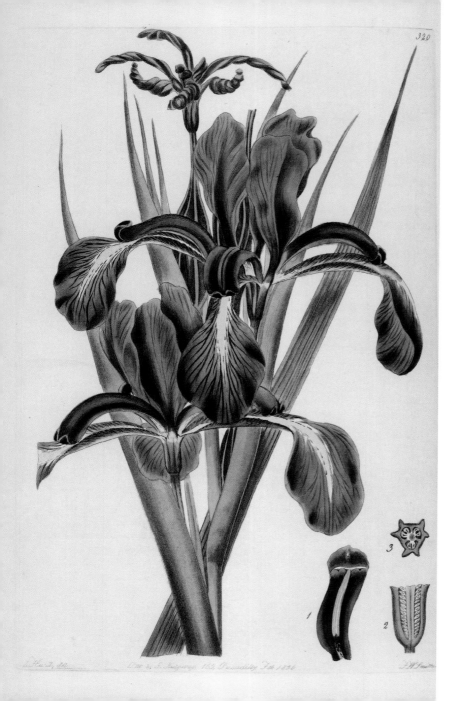

Iris spuria from Robert Sweet's *British Flower Garden*, a multi-volume work that first appeared in 1823, and continued for three years after his death in 1835. Sweet was a nurseryman by training, who set out in this work to publish the description of 'the most ornamental and curious hardy herbaceous plants' with coloured illustrations based on the drawings of E. D. Smith. The *Iris spuria* was a late-flowering iris, cultivated by Philip Miller in 1759, and the example shown here was drawn from a plant in the Chelsea Physic Garden.

PS: *British Flower Garden*, vol. 4, 2nd series, p.32

The Iris

The iris is named after the goddess of the rainbow who, as the link between sky and earth, also acted as the messenger from the gods in Greek and Roman mythology. This is an inspired association, for the flowers come in a huge range of colours, often watery hues. Along with the lily, the iris became a symbol of the Virgin Mary in medieval iconography and sometimes took its place in Annunciation scenes.

Thus the iris has feminine associations, yet one of its characteristics – the pointed, sword-like, leaf – is very masculine. In German, for instance, it is known as the Sword Lily (*schwertlílie*), and in Old English as *segg* and *gladwyn*, again meaning sword. Perhaps it is this military connotation that led Clovis, the fifth-century King of the Franks, to adopt the flower as his badge after winning an important battle over swampy terrain covered with a carpet of yellow irises. In the twelfth century, King Louis VII of France adopted the purple iris as his symbol and this '*fleur de louis*' evolved into the fleur-de-luce and fleur-de-lis, which is often mistakenly thought to be the lily.

Gerard, in his herbal, had no doubt that the fleur-de-lis was the iris, succinctly summing up the great variety on offer:

> There are many kinds of Iris or Floure de Luce, whereas some are tall and great, some little, small and low. Some smell exceeding sweete in the roote, some have no smell at all. Some floures are sweet in smell, and some without: some of many colours mixed: virtues attributed to some, others not remembered: some have tuberous or knobbly roots, others bulbous or onion roots, some have leaves like flags, others like grasse or rushes . . .

IRIS
GERMANICA.

The practical uses of the iris have been known for thousands of years. Gerard's 'knobbly roots' or rhizomes were used to make spices by the Ancient Egyptians, and by the Greeks and Romans to enhance the taste of wine. This practice continued through the centuries, so that the British used the rhizomes of the Stinking Iris in ale and the seeds of the Yellow Flag roasted as 'coffee', while the Italians still use the iris root in the making of the wines of Chianti.

The iris was a prominent occupant of the physic garden because of the purgative qualities of the rhizome. The Greek physician Dioscorides in his *De materia medica*, written in the first century AD, recorded two

Iris germanica from Leonhart Fuchs's *De historia stirpium*, published in Basle in 1542. Fuchs's text was based on the ancient text of Dioscorides, but his illustrations were more valuable, based as they were on living plants, as shown on p.19. It was from Fuchs that Linnaeus got the mistaken idea of a German origin for the iris.
PS: *De historia stirpium*, p.317 (Sherard 646)

types of iris, now known as *Iris germanica* and 'Fiorentina', within the group 'Aromatics'. He advised that they had 'a warming, extenuating faculty, fitting up against coughs, and extenuating gross humours hard to get up. They purge thick humours and choler and heale the foments of the belly.' Centuries later, William Turner in his herbal of 1562 recorded 'This herbe is called in yle of Purbeck [in Dorset] Spourgewort because the juyce of it purgeth.' Rhizomes could also be chewed to counter bad breath, while an external application of the juice was said to remove blemishes and freckles.

Orris, a derivation of 'iris' was the product of drying rhizomes, primarily of *I.germanica*, *I.pallida*, and 'Fiorentina', resulting in a powder that was sweetly scented and reminiscent of violets. This could be used not only as a flavouring in drinks, but also as a fixative to strengthen the scent and flavours of other substances. 'Fiorentina' is named after the city of Florence, where the commercial cultivation of orris was established in the Middle Ages, and where the city's coat of arms is the iris – as is that of Tuscany. Clothworkers and drapers used orris to sweeten their cloths, barbers to perfume wigs, and housewives to give a fragrant aroma to their bedlinen and laundry.

So the iris was a remarkably useful and versatile flower, and of course a very beautiful one. Not only has the iris been muddled iconographically with the lily, but also botanically, with some irises known as a form of lily in the Middle Ages. Both are monocotyledons, plants with one seedling, and their flowers have three parts, but they are very different in leaf form and flower structure. The iris family, Iridaceae, includes over 300 species of wild iris, distributed throughout the northern hemisphere and in a wide variety of habitats from low-lying marshes to mountain pastures. The native British iris is the Yellow Flag, *I.pseudacorus*, whose chosen habitat is near water, so that Gerard called them Water Flags. In Ireland the Yellow Flag was hung on doors for the feast of Corpus Christi to avert evil, and a similar custom is to be found in France on St John's Eve. The Stinking Iris, *I.foetidissima*, may have been

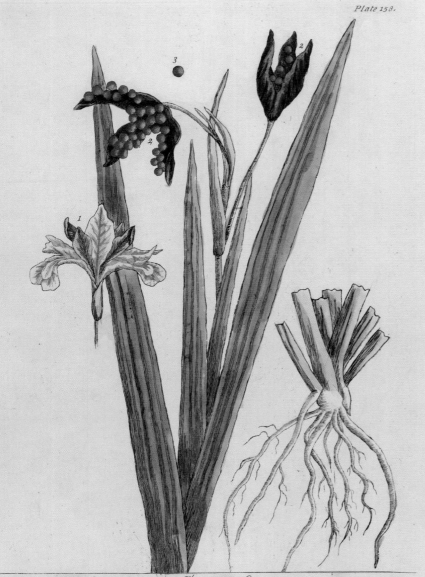

Plate 158.

3

2

1

2

Wild Iris or Stinking Gladwyn. 〕 1. *Flower.* 〔 *Iris silvestris, Spatula foetida.*
Eliz. Blackwell delin. sculp. et Pinx. 〕 2. *Seed Vessel open.* 〔
〕 3. *Seed.*

Elizabeth Blackwell's illustration of the
native British iris, the Stinking Gladwyn
or *Iris sylvestris, spatula foetida*, from her
Curious Herbal, 1751.

PS: *Curious Herbal*, vol. 1, p.158

introduced by the Romans, but has taken up residence in woodlands and sheltered banks. Despite its unpleasant name, it smells more like raw beef when the flowers are crushed, and has a local name of Roast Beef Plant, as well as Adder's Mouths, Bloody Bones, and Dragon's Tongue.

Because of their great practical use, irises were regularly found in monastic gardens in the Middle Ages, but their decorative qualities were also appreciated. Paintings show that by the early fourteenth century irises were grown alongside lilies and roses in Italian gardens. The inventory of a garden of the Hôtel de Saint-Pol outside Paris records the planting in 1398 of 300 individual flag irises.

Until the sixteenth century virtually all the iris species in European gardens were indigenous types of Bearded Iris, or derivations of these. However, the excitement of finding new

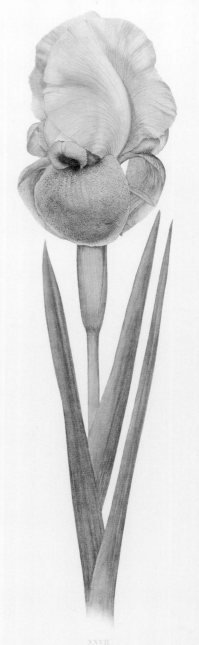

XXVII
Iris Lortetii

Iris lortetti, illustrated by F. H. Round in *The Genus Iris*, compiled by William Rickatson Dykes and published in 1913. Dykes, a schoolmaster at Charterhouse, was the leading iris authority of his time, and in his honour the iris societies of Britain, Australia, and the United States of America have named their highest award 'the Dykes Medal'. *Lortetti*, described by Dykes as perhaps the most beautiful of all irises, was found on high ground in Lebanon.

PS: *Genus Iris*, plate xxvii

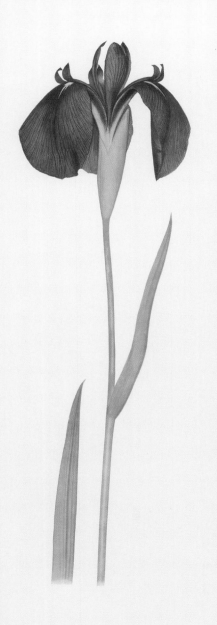

Iris Kaempferi

and unusual varieties was constant. Clusius had a collection of Spanish irises in the Botanic Garden at Leiden, and plant breeders from the Low Countries played a major role in the development of early strains. In the seventeenth century new species were introduced into European gardens, including the first *sibirica* irises, while established varieties were dispatched across the Atlantic to the new colonies in North America.

Perhaps the most tantalizing irises, as far as Europeans were concerned, were from Japan. The Japanese have always greatly venerated the iris, regarding it as a national flower along with the chrysanthemum. One of the first European botanists to visit Japan was Engelbert Kaempfer, sent by the Dutch East India Company in 1690. Because of the stringent conditions imposed upon Western merchants by the Emperor, the Company was allowed only to send two or three ships annually to their base at Deshina, an artificial island connected by causeway to the mainland port of Nagasaki. No

Iris kaempferi from *The Genus Iris*. Known also as *I. ensata*, it was introduced into Europe from Japan by Philipp Franz von Siebold in the 1860s.

PS: *Genus Iris*, plate xix

Elizabeth Blackwell's illustration of the orris, *Iris fiorentina*, from her *Curious Herbal* published in 1751. The story behind the book is equally curious. Elizabeth was the wife of Dr Alexander Blackwell, a physician turned successful printer, who was ruined by a combination of resentful competitors because he had not been apprenticed to the trade. His wife rescued him from a debtors' prison by taking lodging near the Chelsea Physic Garden and, at the suggestion of Sir Hans Sloane, making drawings and engravings for a medicinal herbal. Blackwell was allowed to leave the prison, but then travelled to Sweden, where he was accused of treason and executed.

PS: *Curious Herbal*, vol. 2, p.414

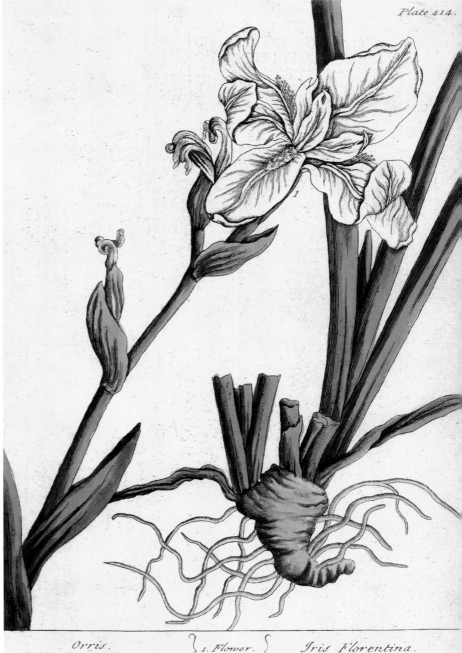

Plate 414.

Orris. } 1. Flower. { Iris Florentina.

Eliz: Blackwell delin. sculp. et Pinx.

social intercourse was permitted, but once a year gifts were sent to Tokyo, providing an opportunity to see the countryside en route. Kaempfer made two such trips, under strict guard, but he was allowed to carry with him a box, in which he put parts of plants to illustrate, and subsequently wrote up an account with illustrations of about 400 plants, including the wild meadow iris, with its characteristically flat flowers.

Seventy years later, Carl Thunberg, a pupil of Linnaeus, was dispatched to Japan to collect plants, and was able to meet scientists in Tokyo and take living specimens back to Holland. When Thunberg published his account in 1784, he named the Japanese iris *I.ensata*, although they are sometimes described as *I.kaempferi* in honour of the doughty Dutchman. For an enchanting display of the Japanese iris, visit Wakefield Place in Sussex at the end of June and beginning of July. A dell containing sixty cultivars has been planted there by the Royal Botanic Gardens of Kew.

In the late seventeenth century, the royal gardener André Le Nôtre used irises, perhaps Bearded Iris, extensively in the gardens of the Tuileries Palace in Paris. He planted them as formal set pieces, and this was the traditional way of displaying irises until the nineteenth century, when gardeners began to mix them informally with other plants as part of the herbaceous border. Gertrude Jekyll, with her painter's eye, particularly appreciated the iris both for its form and variety of colours. At Barrington Court, she proposed not only a lily garden, but also a rose and iris garden. Her planting plan has recently been used by the National Trust as the basis for replanting, so that once more the outer borders are filled with a rainbow of old varieties of Bearded Irises, with Bourbon and Rugosa Roses in the inner beds. The combination of the two flowers is also to be seen in the Rose Garden at Sissinghurst Castle in Kent. In 1949 Vita Sackville-West wrote lyrically of the irises: 'They suggest velvet, pansies, wine – anything you like, that possesses texture as well as colour.'

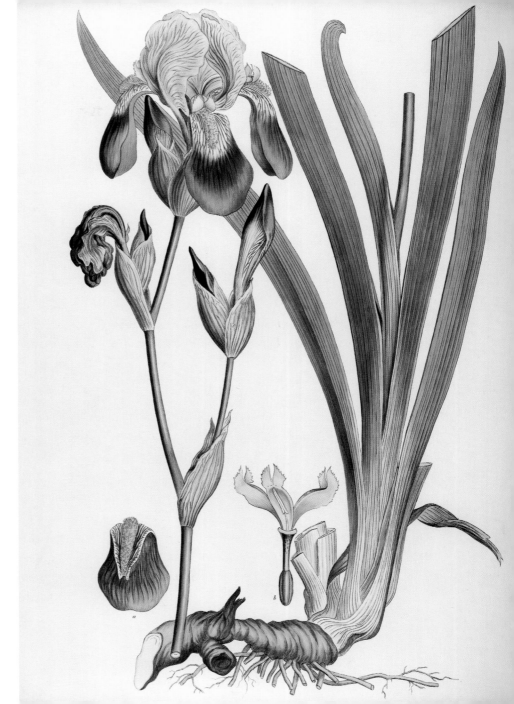

Iris germanica illustrated
by Ferdinand Bauer for
Flora Graeca, 1804 (see
overleaf).

PS: *Flora Graeca*, vol. 1, tab 40
(Sherard 761)

JOHN SIBTHORP AND FERDINAND BAUER

The botanist John Sibthorp was born in Oxford in 1758, the son of the Sherardian Professor of Botany, Humphrey Sibthorp. His father apparently delivered a single lecture in his tenure of thirty-six years, and his contribution to botany is considered to lie principally in producing John, in whose favour he resigned his chair in 1784. The younger Sibthorp much preferred to travel and botanize, or herborize as he put it. In the autumn of 1785, while working with the director of the Botanic Garden in Vienna, Nikolaus Joseph von Jacquin, he was shown a seventh-century illustrated copy of Dioscorides' *De materia medica*, and resolved to study the flora of Greece and identify the hundreds of plants mentioned in the manuscript and confirm their medicinal value. Although much was known about the remains of antiquity, there was less interest in the plants and animals of the area.

Sibthorp was lucky to have as his travelling companion the very talented Austrian botanical artist, Ferdinand Bauer, who has been described as the Leonardo da Vinci of natural-history illustration. Between March 1786 and September 1787 the two men visited Istanbul and Izmir, Athens and many of the islands, though threat of war and the onset of plague made it impossible to travel through the Greek mainland. When he returned to England, Sibthorp brought with him over 2,000 plants with the aim of producing a *Flora Graeca*. However, he was determined to secure additional specimens, so in March 1794 he set out again for Greece. This time Bauer did not accompany him; he had bitterly resented being treated as a servant on their original expedition. The second journey was full of difficulties: Sibthorp suffered from recurrent bouts of malaria and his new botanical assistant, François Borone, was killed in an accident, probably while sleepwalking in their quarters in Athens. Sibthorp continued undaunted in the company of his friend John Hawkins, returning to England in October 1795, but he was desperately ill and died four months later. His plant collections, including the 3,000 species upon which the *Flora Graeca* was later based, is still in the Department of Plant Sciences in Oxford.

Despite his earlier mistreatment, Bauer completed all the illustrations for the project. As John Hawkins wrote at the time, 'As works of Art they are superior to anything of the kind in existence and will constitute one of the most valuable treasures of the University.' One of his most dramatic images is of *I.germanica*. The *Flora Graeca* was printed in ten folio volumes between 1804 and 1840. With 966 plates, and a print run of only twenty-five, the cost of each set was a massive £630, which in today's money might be reckoned at over £25,000. The Bodleian Library published a popular commentary, *The Magnificent Flora Graeca*, in 2007.

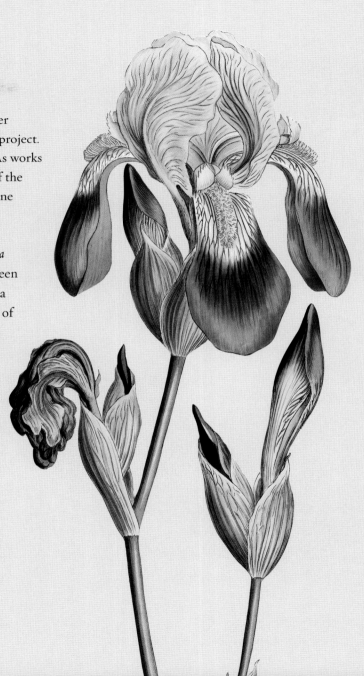

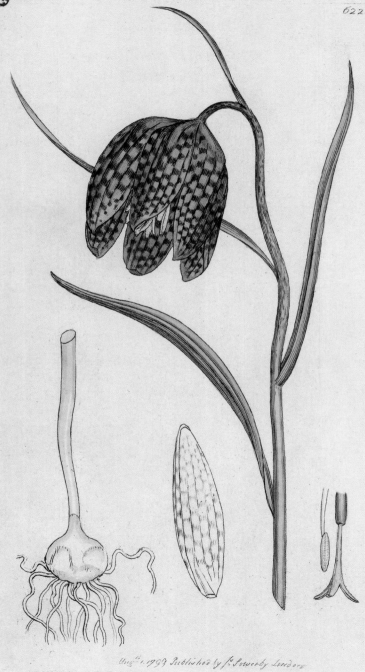

Aug. 1 1799 Published by J. Sowerby London

Fritillaria meleagris from *English Botany*, published in 1790. The illustrations for the book were produced by James Sowerby – a huge undertaking of more than 2,500 drawings, and he may well have worked on the engravings too. The text was provided by Sir James Edward Smith, President of the Linnaean Society. He describes this as the common fritillary and was in no doubt that it was a British native, even though it had passed unnoticed by earlier botanists.

PS: *English Botany*, vol. 9, opp. p.622

The Fritillary

The fritillary known as *Fritillaria meleagris* is a flower of mystery, understated and delicate to look at. One of its mysteries is whether it is a British native. The range of this fritillary runs from Sweden to France, and down to the Balkans, but the first record of it growing wild in England comes in 1736 when it was found in fields near Ruislip in Middlesex. Some botanists therefore think they escaped from foreign plants set in Tudor gardens, others that they were there all the time, quietly growing in meadows. As George Claridge Druce wrote in his *Flora of Oxfordshire*, published in 1886: 'It is not a little singular that the Fritillary, so conspicuous a plant of the Oxford meadows, should have so long remained unnoticed by the various botanists who had resided in, or visited Oxford.'

It was the Dutch botanist Dodoens who called them *meleagris* because each segment of their perianth looked like the feather of a guinea fowl, while the French physician and botanist Matthias L'Obel chose *Fritillaria* from *fritillus*, or dicebox, although to be more accurate their pattern resembled the table on which chess or checkers was played. John Gerard, who was given his fritillaries by the French royal gardener Jean Robin, wrote in his herbal in 1597, 'These rare and beautiful plants grow naturally wilde in the fields about Orleance and Lions in France,' and added that they prospered as well in his garden as in 'their owne native countrey'. With guinea fowl in mind, he called them 'Ginny hen' and 'Turkie hen' flowers, as well as 'checkered daffodils'.

Gerard Manley Hopkins, acute in his botanical observation, described the fritillaries seen near Oxford in 1864, 'Snake's-heads like drops of blood. Buds pointed and like snake's heads, but the reason of name from mottling and scaly look.' Snakeshead is how they are now most commonly known, though

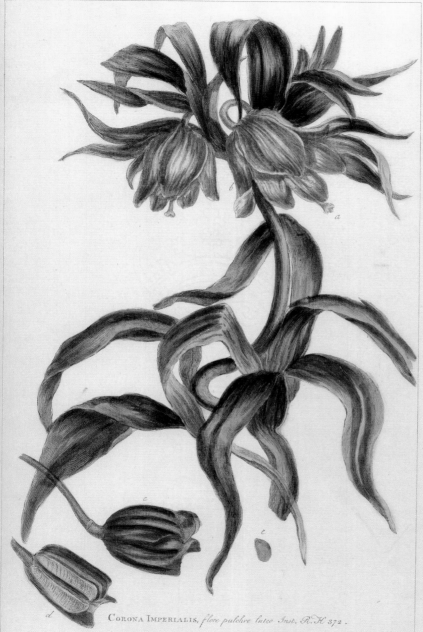

CORONA IMPERIALIS, *flore pulchre luteo* Inst. R. H. 372.

R. Lancake delin.

J. S. Miller sculp.

Publish'd according to Act of Parliament by P. Miller August 24. 1756.

The Crown Imperial, *Fritillaria imperialis*, in Philip Miller's *Figures of Plants*, 1771 (see pp. 100-101). Miller notes, 'This plant was originally brought from Persia to Constantinople, and from thence was introduced into these Parts of Europe, about the Year 1570 . . . they are now so well inured to this Climate, as to thrive as well as in their natural places of Growth.'

PS: *Figures of Plants*, plate cv

the English bestowed upon them all kinds of names, not always complimentary: Dead Men's Bells, Death Bell, Doleful Bells of Sorrow, Drooping Bell of Sodom, Weeping Widow. Sometimes they were known as Bloody Warriors, because it was believed that they grew from drops of blood shed by Danish invaders. Perhaps all this sinister talk was connected with the fact that the corms, uncooked, are poisonous.

Meanwhile the Snakeshead's flamboyant cousin had arrived in Western Europe. In complete contrast, the *F.imperialis* or Crown Imperial is large and stately, with flowers ranging from yellow through orange to red. A native of the Holy Land, its flowers are said to hang their heads in shame because they stared boldly at Christ on his way to the Crucifixion. The Crown Imperial travelled westwards via Turkey, arriving at the Imperial Gardens in Vienna *c.*1580. It was one of a whole series of exotic plants that were being dispatched in the diplomatic bags, as it were, of ambassadors to the court of the Ottoman Sultan. Sixty years earlier Selim I had seized power from his father, and closed the trade routes, obliging European merchants to find alternative sea routes. But the overland routes were much easier and safer, so diplomatic ties were established. The Habsburg ambassador, the splendidly named Ogier Ghiselin de Busbecq, sent back to Vienna the Crown Imperial, along with the first cultivated tulip and the *Codex Vindobonensis*. The English ambassador, William Harborne, posted parcels of bulbs back to the Secretary of State, Sir William Cecil, who then passed them to his gardener, John Gerard.

Although Sir Thomas Hanmer put Crown Imperials in the centre of one of the beds in his mid-seventeenth-century garden at Bettisfield, he was not a great admirer, finding their orange colour 'ill dead', while others thought that the corms smelt of fox, and gave them the name of Stink Lily. Hanmer also planted grey fritillaries, probably *Fritillaria persica*, which too was introduced to Europe via Constantinople.

Dutch artists liked to contrast the drooping nature of the Snakeshead Fritillary with the upright character of the tulip in seventeenth- and eighteenth-century Delft tiles, as well as in their flower-pieces. The Arts and Crafts artist Charles Rennie Macintosh likewise appreciated the geometric patterning in his botanical designs at the end of the nineteenth century.

In gardening, the fritillary was used by André Le Nôtre in the formal layouts he produced for Louis XIV, alongside carnations, tulips, irises, and lilies, but it really came into its own with the development of the wild garden. In his garden at Gravetye Manor in Sussex, William Robinson planted large quantities of fritillaries with his tulips and narcissi. In *The Wild Garden*, published in 1870, he recommends eight forms of the fritillary – white, yellow, various purples, and double flowers, but particularly commends the Snakeshead Fritillary, suggesting planting it in lanes, to cover banks and old trees, and in the meadows of 'a country seat'.

By the twentieth century, wild fritillaries were under threat. As their seed is flood borne, they favoured the damp meadows around Oxford, and especially those belonging to Magdalen College, where they were carefully recorded in 1785. But A. H. Church, lecturer in botany at the University, recorded in 1925 how the general public, and especially schoolchildren, were 'affected by a mania for picking the plant as soon as it appears', and selling them on the streets for a couple of pence a bunch. 'A score of small boys taking large bunches of buds with little colour, at an estimate of 500 per child, will thus denude a couple of acres in an afternoon.' He was supported in this grim view by Dr Turrill of Kew, who attributed blame not to over-enthusiastic schoolchildren but to people taking daytrips in their cars. In the *Lily Year Book* in 1951 he reported that there was scarcely a blossom to be found in the meadows between Oxford and Iffley. The one honourable exception was the Magdalen meadows, where careful conservation had been practised by the College. Today the show of fritillaries in late spring is magnificent here, with the dotted splashes of purple and white against a lush green backdrop.

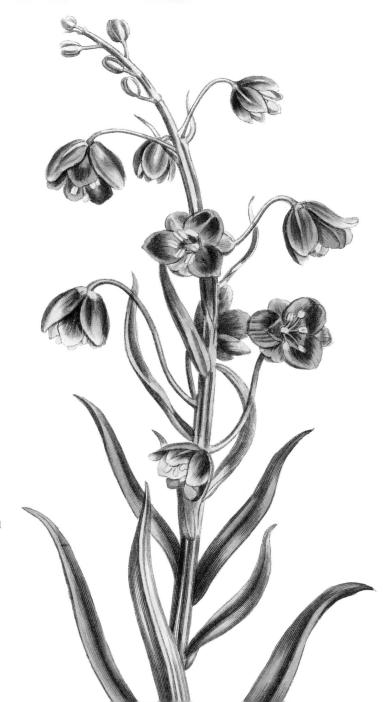

Fritillaria persica from *Curtis's Botanical Magazine*, 1806. Curtis noted that this was probably of Persian origin, but that John Parkinson attributed its introduction to England by merchants from Turkey. He also pointed out that the roots did not have the rank smell of the Crown Imperial or Stink Lily, but were bitter to the taste.

PS: *Curtis's Botanical Magazine*, vols. 23-4, tab 962

ROBERT MORISON

Robert Morison was born in 1620 to a family who intended him for the Church, although his great interest lay in botany. When the Civil War broke out, he was wounded while fighting for the Royalist cause and fled to France, where he was able to turn misfortune into the opportunity to study anatomy, botany, and zoology, and to practise horticulture in the gardens at Blois of the Duc d'Orléans, uncle of Louis XIV. Here he was encouraged to develop his ideas for the classification of plants, and he continued this work in England with the Restoration of Charles II in 1660, when he became the King's royal physician and professor of botany.

In 1669 Morison was elected the first professor of botany at Oxford. The University was determined to advance the reputation of its press through the publication of an ambitious herbal organized according to his new principles of taxonomy. Three years later he published a specimen of this work, *Plantarum umbelliferarum distributio nova*, dedicated to the University's chancellor, with some plates paid for by the delegates of the press and the rest by members of the universities and College of Medicine in London. The page of fritillaries shown here has the coat of arms of Samuel Collins of Trinity College, Cambridge, Fellow of the College of Medicine. Both the engraver, William Fairthorne, and the botanical artist, William Senmans, are also credited.

Although a brilliant scholar, Morison seems to have been a difficult individual. The botanist John Ray did not have the benefit of a physic garden at Cambridge, and Morison accused him of studying more in the

closet than the garden. Ray never spoke to him again. In the event, Morison did not complete his huge project, for he was knocked over by a coach in the Strand in London and killed in 1683. Of the three volumes planned, the first remained unpublished, the second was produced by the press in 1680, and the third was eventually completed as *Plantarum historiae universalis pars tertia* by Jacob Bobart the Younger (p. 42), appearing in 1699.

PS: *Plantarum umbelliferarum*, Section 4, tab 18 (Sherard 726)

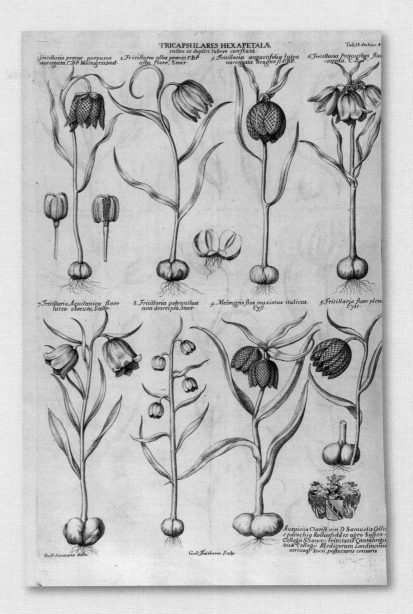

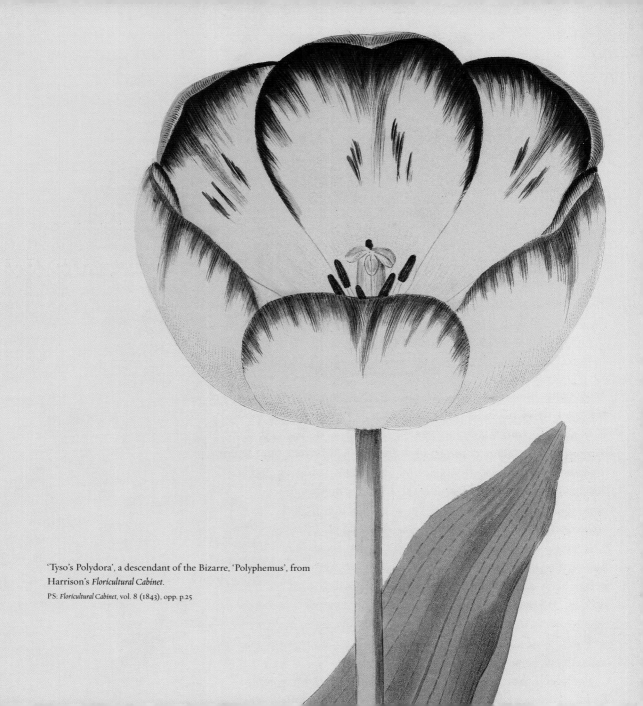

'Tyso's Polydora', a descendant of the Bizarre, 'Polyphemus', from Harrison's *Floricultural Cabinet*.

PS: *Floricultural Cabinet*, vol. 8 (1843), opp. p.25

The Tulip

Early seventeenth-century Dutch portraits show men and women in sober dress of black and white, caution emanating from their faces. It is odd therefore that the young nation of the United Provinces should have fallen into the grip of a mania. But if the Dutch were going to have one, perhaps it is appropriate that it was floral; one explanation for its cause is that the Dutch have always loved having flowers in the house. The Cornish traveller Peter Mundy noted how difficult it was to walk in the countryside, so that the Dutch indulged in 'home delights, as in their streets, houses, roomes, ornaments, Furniture, little gardeins, Flower Potts, in which latter very curious off rare rootes, plants, Flowers, etts [etc]; incredible prices For tulip rootes'. What they called the 'wind trade', we know as tulipomania.

The tulip was the most prized of the bulbs sent to Vienna by Ogier Ghiselin de Busbecq, the Flemish aristocrat who acted as the Holy Roman Emperor's ambassador to the court of Süleyman the Magnificent in Constantinople. Turkish tulips derived from wild species, probably from different parts of the Ottoman Empire, including the Siberian steppes, Afghanistan, and the Caucasus, that had undergone targeted breeding. In Constantinople florists' councils adjudicated admission of new varieties to the official tulip list, and they were given exquisite names, such as 'Matchless Pearl' and 'Slim One of the Rose Garden' and 'Those that Burn the Heart'. Prize flowers were displayed as single blooms in narrow-necked vases called *laledan*, from the Turkish for tulip, *lale*. In Arabic script *lale* has the same letters as Allah, and just as man should bow his head before God, so the tulip bowed its head when in full bloom. Süleyman's robes were embroidered with tulips, and Iznik ceramicists took the distinctive shape of the flowers favoured by the Turks, with thin waists and pointed petals fanning out like needles, and painted them on tiles and vases.

On his first journey to Constantinople in 1554, Busbecq described the bulbs that he dispatched to Vienna as *tulipam* rather than *lale*. It is thought that as the flowers were worn by Turks in their turbans, *tulband*, Busbecq misunderstood his interpreter, hence the confusion. But tulips had been mentioned even before the publication of Busbecq's diaries, and therefore the exact time of their arrival in Western Europe remains unclear. Indeed, some species of the genus were native in the West, for instance in the Savoy area of France, but it was the flowers bred by the Ottomans that really enchanted Europeans.

In 1559 the great Swiss naturalist Conrad Gesner, having seen a tulip flowering for the first time, in a garden in Augsburg, recorded the gleaming red petals and the delicate scent. His

One of the first images of the tulip produced in Europe appeared in Pierandrea Mattioli's 1565 edition of his commentaries on Dioscorides' *De materia medica*, published in Venice. He classified this new exciting flower as a narcissus.
PS: *Commentarii*, p.1244 (Sherard 655)

description was published two years later, along with the first illustration in Western Europe. As a result, Linnaeus was to call the plant *Tulipa gesneriana*. The person perhaps most responsible for spreading the tulip through Europe was Carolus Clusius, who planted tulips received from Busbecq in his garden in Vienna.

Despite the fact that it takes between five and seven years for a seedling bulb to reach flowering size, European gardeners immediately began to develop selection. And the tulip of all flowers responds in abundance to such treatment. An aphid-carried virus, only identified in the 1920s, enabled the fantastic variety of breaks in colour and pattern, such as feathering, that made the tulip so alluring. Europeans were already fascinated by oddities and colour variations in native plants such as primulas and carnations. When the tulip began to show such signs, the Dutch were hooked. John Gerard in 1597 grouped tulips into fourteen categories, protesting that to try to describe all the varieties would be to 'number the sands'. Thirty years later, Parkinson outlined a classification of sixteen major forms, with forty-nine cultivars of *T.praecox* (early flowering), seventy of *media* (mid-season), and five *serotina* (late). Another thirty years, and John Rea listed 184 varieties.

The Dutch were reputed to love gambling, and particularly indulged in lotteries. Thus, when it transpired that the tulip could be so unpredictable, their passion began to kick in. The value of the flamed and feathered tulips was based not only on their beauty, but also their rarity, because they could not be reproduced as quickly as solid colours. Three categories became particularly desired: the Rosen or Roses, scarlet, pink, or crimson streaks on white; the Violetten or Bylbloemen, mauve, purple, or black on white; and the Bizarden or Bizarres, any colour of flame or feathers on a yellow ground. The Rosen was the rarest, and by the 1620s the most expensive example was 'Semper Augustus'. A century later, the chronicler of the tulip, Nicholas van Wassenaer, wrote of it, 'No tulip has been held in higher esteem, and one has been sold for thousands of florins.'

LIBER SECUNDUS, SECTIO SECUNDA.

TULIPÆ ET EJUS SPECIES.

flavo nigricantibus, aut flavis, aut ex viridi nigricantibus, aut fubcæru-
leis, vel ex cærulco flavefcentibus, aut cærules, orbe flavefcente ambien-
te: Sunt & dilute purpurei & remiffe miniati, aurei mali coloris, & vel
dilutiores interné & per oras vel faturatiores: interdum interné diluriffim,

Tulipa flore carneo, purpureis & albis lineis,
liffärga Tulpan med hwita och purpur ränder.

O 2

Tulipa dubia flore albo, lineis carneis & purpureis.
Dwel Tulpan med liffärga och purpur ränder.

Two tulips from Olof Rudbeck's *Campi Elysii*, published in Upsala in 1701–2. This was the last botanical book of importance that used woodblocks, and the artist has skilfully shown the complex patterning of the petals that so impassioned tulip enthusiasts at this period. The tulip on the right is a double variety, which became fashionable at the end of the seventeenth century. Rudbeck, founder of the Botanic Garden at Upsala, began to prepare his book in the 1670s, intending to produce twelve volumes, with over 11,000 drawings. *Campi Elysii* was in production when the whole city went up in flames, and Rudbeck died months later, heart-broken. By great good fortune, a proof copy of the first volume had been sent to Oxford, and this was returned to Sweden in the nineteenth century to make a new edition of the book.

PS: *Campi Elysii*, p.107 (Sherard 744)

Initially tulip sales took place in summer after flowering and the lifting of the bulbs, and before replanting. But by the 1630s, the trade had become speculative, with bulbs sold in anticipation, before lifting, by middlemen who held auctions in taverns. Tulipomania reached its climax during the winter of 1636/7 when a 'Semper Augustus' fetched 10,000 guilders. An estimation of what this meant in terms of a total of other commodities has passed into legend: eight pigs, four oxen, twelve sheep, twenty-four tons of wheat, forty-eight tons of rye, two barrels of wine, four barrels of expensive beer, two barrels of butter, 1,000lbs of cheese, a silver cup, clothes, a bed complete with bedding and mattress, and a *nef*, an elaborate salt cellar in the shape of a ship. Another perspective is to realize that the tulip trade was valued at about three times that of the Dutch East India Company, Europe's leading trading organization.

As with the pricking of the South Sea Bubble in early eighteenth-century Britain, the tulip trade suffered a spectacular crash; the state of Holland tried to intervene to cancel debts and calm the situation. Like ripples in a pool, there were further bouts of tulipomania, in France and Turkey in the eighteenth century, and in England in the early nineteenth, but none had the same catastrophic effects. Although men were ruined by the trade, as described by Alexandre Dumas in his 1850 novel, *The Black Tulip*, the flower also inspired Dutch and Flemish flower painters such as Jan 'Velvet' Breughel and Ambrosius Bosschaert, who delighted in portraying the flamboyant forms and colours. In early herbals, the restrictions of woodcut limited the drama of the tulip but the introduction of metal engraving enabled the fluidity of form of the tulip to be portrayed, and when hand-coloured, the glory of the colour and pattern came into full force.

To display tulips in all their glory, the Dutch developed lavish vases in delftware, the highest quality coming from the Greek A factory in the late seventeenth century. The most elaborate forms are to be

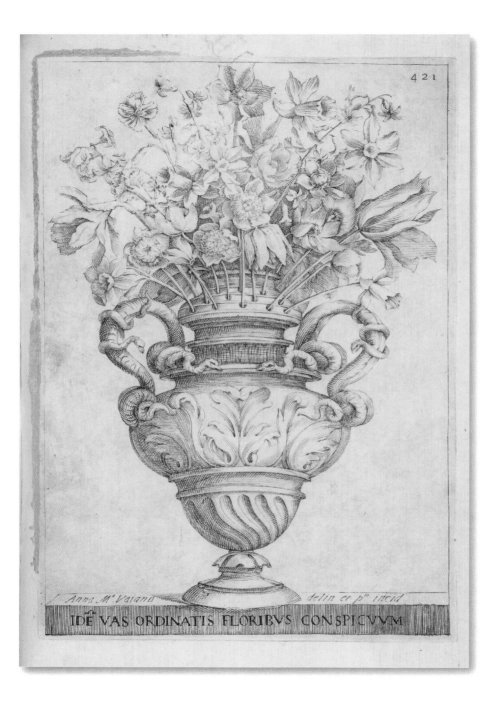

Anna M.ᵃ Vaiana delin et pⁿ incid

IDẼ VAS ORDINATIS FLORIBVS CONSPICVVM

When Giovanni Battista Ferrari published his *Flora, overo cultura di fiori* in Rome in 1638, he not only reproduced illustrations of flowers, but also designs for gardens and equipment. A man of many parts, he combined the professorship of Hebrew and rhetoric at the Jesuit College in Rome with advising the Pope on horticultural matters. Among the artists that he employed to work on the copper-plate illustrations for his book was Anna Maria Variana, thought to have been the first female engraver. This illustration shows a vase in the fashionable baluster shape with a lid through which flower stems were inserted. The lid could be removed to change the water in the arrangement, keeping the flowers still in place. Ferrari stipulated that the most beautiful flower should crown the vase, just as a beautiful head of hair crowns a body.

PS: *Flora, overo culturadi fiori* - vase, p.421 (Sherard 459)

seen at the palace of Het Loo near Apeldoorn in Holland, collected by Prince William of Orange and his English bride, Mary Stuart. When they ascended the English throne as William and Mary, they brought the fashion for blue-and-white vases to London, and another of their collections is shown at Hampton Court Palace. Perhaps the most familiar shape is the pyramid vase, with removable tiers so that water could be kept topped up for the flowers. This is also known as a tulip vase, although other flowers might be used for display.

Tulips were grown in English gardens by the end of the sixteenth century. In 1597 Gerard described in his herbal how his friend James Garret, a Fleming who became a London apothecary, had been growing them for twenty years. Dutch immigrants bought their bulbs from Flanders and France, where they were mostly raised in monasteries. This, too, was the source of the tulip bulbs grown by Sir Thomas Hanmer. When the Royalist cause was doomed in the Civil War, he retired to his estate of Bettisfield in Flintshire and cultivated his garden. His parterres included many different flowers, but tulips were possibly his favourite. His particular triumph was the 'Agate Hanmer', greyish purple, deep scarlet, and pure white, and described by fellow enthusiast John Rea as, 'commonly well parted, striped, agated and excellently placed, abiding constant to the last, with the bottom and stamens blue'. He was so proud of this tulip that he presented bulbs to friends such as the diarist John Evelyn, and, raising himself above political conflict, gave a root to the Parliamentarian Major General John Lambert, for his garden at Wimbledon Manor. When a satirical pack of playing cards was produced by the Royalists to denigrate Oliver Cromwell and his colleagues, the Lord Protector was shown as the Ten of Clubs, 'seeking God while the King is murdered by his order', and Sir Henry Mildmay as the King of Diamonds, philandering with another man's wife. Lambert, on the other hand, was treated very gently, as the Eight of Hearts, the Knight of the Golden Tulip, standing in his garden holding his favourite flower.

The tulip was one of the first to be identified as a florist's flower. In *The Seasons*, his hugely popular poem published in complete form in 1730, James Thomson encapsulates what was so attractive to florists:

> . . . then comes the tulip race, where beauty plays
> Her idle freaks: from family diffused
> To family, as flies the father dust
> The varied colours run: and while they break
> On the charmed eye, the exulting Florist marks
> With secret pride the wonders of his hand.

Unlike gentlemen gardeners such as Hanmer and Rea, florists could not afford to buy bulbs from European nurserymen, so grew their tulips from seed, waiting for seven years for a flowering bulb to develop. The shape favoured by florists was rounded, like a globe, in complete contrast to the Turkish lily shape. As in early seventeenth-century Holland, three groups of tulips were particularly prized: Roses, Bybloemens, and Bizarres. These provided a framework within which judgements could be made at tulip shows. The earliest recorded show was held in Suffolk in 1740, and a Tulip Society was established in York in 1768, but perhaps the great period came in the early nineteenth century when a mini-tulipomania overcame amateur gardeners. One enthusiast was the Dulwich florist, William Clark. He raised two famous 'fancy tulips': 'Fanny Kemble', a Bybloemen with dark, almost black markings on a white ground, that caused a sensation when it first appeared in the 1820s; and 'Polyphemus', a Bizarre with dark purplish-brown markings on a lemon ground. These were both used as parents in crosses, and Lancashire growers referred affectionately to the latter as 'Polly'.

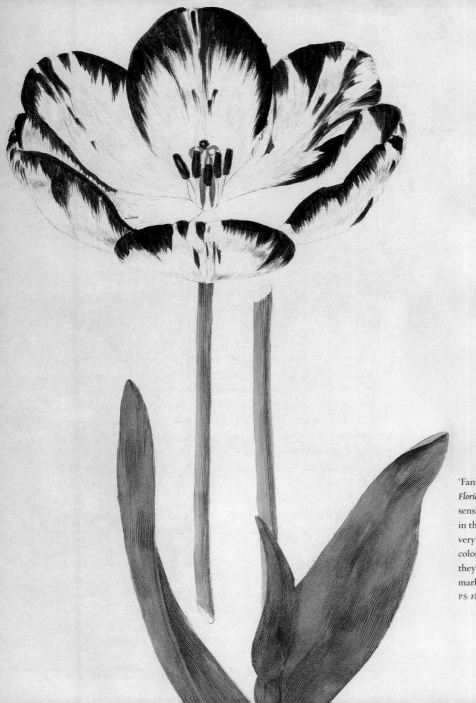

'Fanny Kemble' from Joseph Harrison's *Floricultural Cabinet*. This Bybloemen caused a sensation amongst florists when it first appeared in the 1820s. Harrison's artist has produced a very stylized outline of the flowers, and as the colours were such an important ingredient, they have been painted in by hand to show the markings.

PS: *Floricultural Cabinet*, vol. 1 (1833) plate x

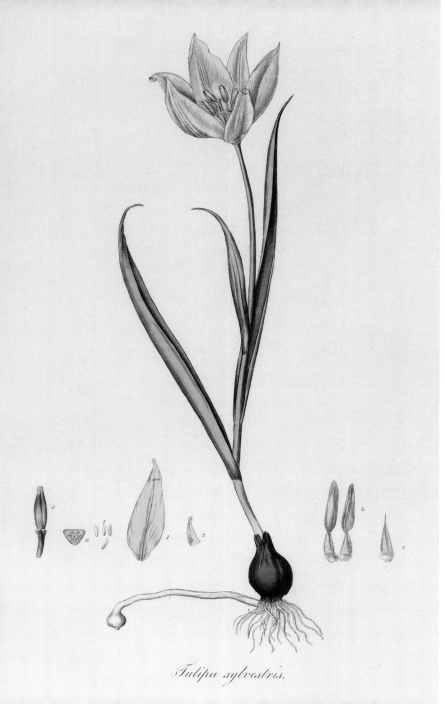

Tulipa sylvestris

Tulipa sylvestris from William Curtis's *Flora Londinensis*, volume 5, 1835. Curtis notes that this species of tulip, which he felt was a naturalized plant rather than 'an aboriginal native', was to be found across many parts of the country, including Bedfordshire chalk-pits and on Muswell Hill just to the north of London. This tulip is now thought to have been introduced into Britain. The interest in the home-grown wild plants, as opposed to the exotic and rare, was taken up by botanists and publishers in different parts of Europe: for example, in Russia with Carl Friedrich von Ledebour's *Icones plantarum novarum . . .*, 1829–34; and in Spain with Edmond Boissier's *Voyage botanique dans le midi d'Espagne*, 1839–45.

PS: *Flora Londinensis*, vol. 5

In the *Account of Flower Shews* of 1826, twenty-seven shows were recorded, held by tulip societies mainly in the industrial cities in the North of England and the Midlands. The numbers increased through the century, but of the hundreds that existed, only one survives, the Wakefield and North of England Tulip Society. Founded in Wakefield in Yorkshire in 1836, its membership was originally dominated by shoemakers. Fourteen years later, a National (later Royal) Tulip Society was formed to reconcile the differences that had arisen between florists from the North and the South. While northern societies focused on symmetry and the beauty of marking, their southern counterparts looked for the shape of the flower and purity of bottom colour. In 1936 the Royal Tulip Society handed over its assets to the Wakefield and North of England, who still hold their annual show in May. Single blooms are displayed, as with Ottoman tulip growers in the fifteenth and sixteenth centuries, but instead of *laledan*, brown beer bottles are used.

In the late nineteenth century the baton of tulip breeding once more passed to the Dutch. The Haarlem nurseryman E. H. Krelage introduced what became new divisions in the ever-more-complex classification of tulips. The

Darwin was bred in the 1880s, followed by Rembrandts, Triumphs, and the lily-flowered tulip, which echoes the thin-waisted, dagger-petalled blooms so beloved by the Turks. These new varieties of cultivars, along with many older styles and species of tulips are to be seen in the garden at Sissinghurst Castle in Kent, created in the 1930s by Vita Sackville-West and Harold Nicolson.

The tulip is a versatile flower for the gardener, effective both as part of a mixed planting, or dominating the selection in a container. In the Cottage Garden at Sissinghurst, where the colour scheme reflects the rich hues of a sunset, the National Trust now opens the annual display with tulips teamed up with wallflowers. The cultivars include the maroon-purple 'Black Parrot', the lily-flowered 'Aladdin' in vermilion edged with yellow, the yellow Darwin hybrid 'Flower of Spring', and the red Triumph 'Casinii'. Vita's idea of a cottage garden has been likened to Marie Antoinette and her attendants playing at milkmaids in the Petit Trianon at Versailles. Certainly the copper that forms the centrepiece of the garden is rather superior to most containers owned by cottagers. In spring it is planted with the lily-flowered 'Red Shine'.

More tulips in containers make a dramatic appearance in the Lime Walk at Sissinghurst. This was the only 'garden room' there planted solely by Harold Nicolson, who called it 'My Life's Work'. Nicolson was particularly interested in the old florists' flowers, and had in his mind's eye the flower paintings of the Dutch masters, planting auriculas, roses, narcissi, and anemones. In his pots he selected varieties of striped tulips that have now almost disappeared, so today they are planted with 'Red Shine' and white forget-me-nots. These rise like punctuation marks in the borders flanking the walk, while a whole host of other tulips are mingled with other flowering bulbs. Around the trunks of the lime trees are planted smaller flowers, including the species *T.tarda*.

For swaths of tulips on their own, however, the enthusiast must return to Holland. The Keukenhof – kitchen garden – of the estate once owned by Jacqueline of Hainault has magnificent displays of tulips from mid-April. The brainchild of the mayor of the nearby town of Lisse, it provides an opportunity for tulip growers to show off their hybrids in what is known as the Garden of Europe.

CAROLUS CLUSIUS OR CHARLES DE L'ECLUSE

As prefect of the imperial medical garden in Vienna, Clusius was ideally placed to receive and cultivate the new and exciting bulbs that were being dispatched from Constantinople, many from the Imperial ambassador, Busbecq. Life became less congenial in 1576 with the death of the Habsburg Emperor, Maximilian II, and the accession of his son Rudolf, a Catholic zealot and alchemist. When the new Emperor tore up his garden to make way for a riding school, Clusius decided it was time to leave Habsburg service, departing first to Frankfurt and then to Leiden. In the late 1580s he departed from Vienna, first to Frankfurt am Main, and then to Leiden. At the latter he was appointed professor at the University of Leiden and helped to create the botanic garden there.

The practice of attaching a botanic garden to the university's medical school had begun half a century earlier, at Padua and Pisa, but the innovation of Clusius' garden at Leiden was to broaden the focus so that the medical plants formed only about one-third of the whole collection. The garden's plants were grouped according to their characteristics, and this logical arrangement, based on careful observation, also informed his great publication, *Rariorum plantarum historia*, published by the house of Plantin in Antwerp in 1601.

The title page, shown here, features the classical scholars, Theophrastus and Dioscorides, along with some of the exciting new plants, such as the tulip, the *Lilium chalcedonicum,* and *Fritillaria imperalis*, that Clusius had received from his huge network of correspondents. It is fitting that the tulip enjoys pride of place, for Clusius played a fundamental role in distributing new varieties of the bulb across Europe, many of which he had raised in his own gardens. With his medical training, he experimented with eating tulip bulbs, and even had some preserved in sugar so that he could enjoy them as sweetmeats. The species tulip named after him, *T.clusiana*, was sent to Florence from Constantinople in 1606, and by the following year it was flowering in his garden at Leiden.

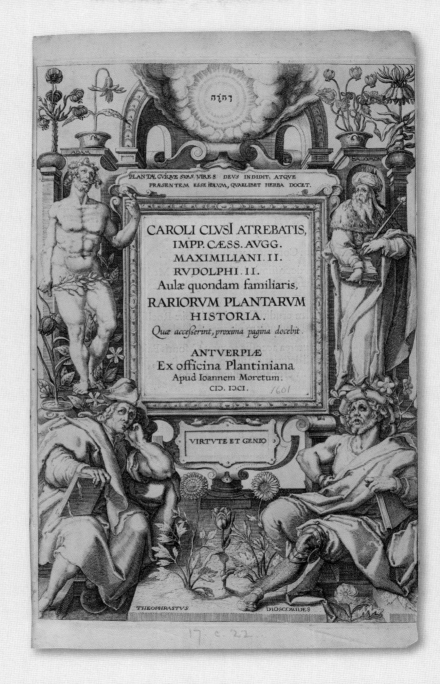

The Hyacinth

The passion for tulips, known as tulipomania, is well known, but a similar passion for hyacinths is not part of our common parlance: probably just as well, for hyacinthomania does not trip off the tongue. In the late seventeenth century the Dutch, French, and English began to develop their passion for the hyacinth, *Hyacinthus orientalis*, relegating the tulip to second place. However, the financial crash of 1637 was not repeated, for florists had learnt their lesson.

The Roman writer Ovid in his *Metamorphoses* offers two myths to show how the hyacinth got its name. In the first, the flower was born of the blood of Ajax, who took his own life when he failed to secure Achilles' weapons in a contest with Odysseus. In the second, Hyacinth was a beautiful young man with whom Apollo was in love. During a game of discus throwing, the god accidentally strikes Hyacinth, and transforms the blood gushing from him into a flower. From these two stories, the hyacinth gained a funerary connotation, but also a link with prudence and wisdom because Apollo was the god of the Muses. In Christian iconography, in contrast, the hyacinth is often depicted in Nativity scenes as the flower that was regarded as a symbol of Christ.

The hyacinth was one of the treasure trove of flowering bulbs given to Europeans by the Ottoman Turks. Sir John Chardin, an Anglo-French merchant, described seeing blue and white hyacinths

Coloured engraving of hyacinths from Robert Thornton's *Temple of Flora*, 1807. Thornton explained that he had placed the hyacinths against a Dutch landscape, 'where these flowers are particularly cultivated embellishing a level country'. The hyacinths featured here are 'Don Gratuit' (single blue), 'Velours Pourpre' (double dark blue), 'Globe Terrestre' (double light blue), 'L'Héroïne' (double white), and 'Diana van Ephesson' (double white with red spots).
PS: *Temple of Flora*

ΥοσκύαμΘ

Hyoscyamus flauus
Bilfomen
Iusquiane, ou Hanebane iaune

Yellow
Henbane

Υάκινθ

Hyacinthus cœruleus maior mas
Bros blaw Mertzenblum mennle
Iacinthe ou vaciet masle grand

Great
male
Bleu
Iaciath

hh

A hyacinth looking like a bluebell, with a yellow henbane, from Leonhart Fuchs's *Stirpium imagines*, published in Lyons in 1549. This is a pocket version of his *De historia stirpium*, published seven years earlier. In sextodecimo (16mo) format, the book could be used for reference in the field, or the surgery.

PS: *Stirpium imagines*, pp. 480-1

growing naturally in Persia on his journeys there in the 1660s. The Ottoman Sultan Murad III in 1563 ordered that 50,000 hyacinths be brought from the mountains to Constantinople, where they were planted in the Topkapiseray and in the gardens of villas along the shores of the Bosporus.

The first hyacinth to arrive in Western Europe was probably cultivated in the Botanic Garden at Padua shortly after its foundation in 1545. Although Clusius obtained bulbs directly from Constantinople, many other botanists acquired theirs through the Florentine dealers. Matteo Caccini, who also gave Clusius the tulip that came to bear his name, *Tulipa clusiana*, was a noted dealer in hyacinths.

The Turks liked their hyacinths to be long and gently curving, looking rather like the native English bluebell, as can be seen in the Ashmolean flower-piece by Ambrosius Bosschaert (p. 6). But double forms began to be developed by seed raising and selection early in the seventeenth century. Parkinson in his 1629 edition of *Paradisi in Sole* described hyacinths of blue, white, and purple, some in semi-double form. Many of the earliest varieties came in reds and pinks, echoing the stories of blood passed down by Ovid.

The Dutch firm that specialized in hyacinths was that of the Voorhelm family in Haarlem. Peter Voorhelm, working on the breeding of the flowers in the 1680s, at first threw away double forms as worthless, but fell ill one winter and on his recovery found one that took his fancy. The third variation from this bulb produced 'Koning van Groot Britanien', named in honour of William III, King of Great Britain but also a Dutchman. Through hybridization, the stem had shrunk in width, while the bells had compacted to produce the highly scented flower heads that are familiar to us. The shape was also developed to produce a pyramidal effect, rather like the full-bottomed wigs worn by men at the end of the seventeenth century.

Peter Voorhelm in 'Koning' produced a marked contrast between the white outer and red inner petals. During its seventy-year life, 'Koning' traded for thousands of florins, over £100 in today's money, though the market never reached hysterical proportions. Another variety, a flesh-coloured hyacinth, was named after the unfortunate Admiral Byng, who was shot on his own quarterdeck for failing to relieve Minorca from the French in 1757. Many nurserymen in London took part in the lucrative trade, importing bulbs from the Netherlands. Robert Furber, in his *Flower Garden Display'd*, published in 1732, portrayed various varieties that were available at his Kensington Gore Nursery (see illustration, p. 38). Later in the century, Robert Edmeades, who ran a seed and gardening business in Fish Street Hill in the City produced a catalogue listing over 1,200 varieties. One, named 'Goldmine', came in red, purple, and scarlet, and cost £15 a bulb. At this time, a clerk in the City could hope to earn an annual salary of £60, while apprentices were paid between 4s. and 16s. per week.

Hyacinths were among the flowering bulbs planted by Sir Thomas Hanmer in his garden at Bettisfield in Flintshire. Here he grew them in rectangular beds, slightly raised, and supported by coloured boards. Louis XIV, the 'Sun King', particularly liked scented plants, so hyacinths featured strongly in the gardens of the Grand Trianon at Versailles. Along with tulips and white narcissi, they were planted in a regimented manner, with each bed surrounded by hedges of box.

The hyacinth became a florist's flower and was sometimes shown at the same florists' feasts as auriculas and polyanthus. Thus when the Ancient Society of York Florists was founded in 1768, hyacinths were exhibited at the first show. However, they were appreciated less for competition and more for cultivation in the flower border and for display indoors. Unusually for a florist's flower, the pattern of the individual flowers was considered less important than the overall shape, and stripes or distinct patterns were discouraged.

It was Nehemiah Grew, the Coventry physician and botanist, who noted in his *Anatomy of Plants*, published in 1682, that hyacinths and tulips could be 'forced' to flower in winter by keeping the plants warm, or as he delicately put it, 'enticing the young lurking flowers to come abroad'. The *Anatomy of Plants* was a pioneering book in many ways, for Grew was one of the first to establish the sexuality of plants. His note of forcing was taken up fifty years later by Martin Treiwald, a Swedish scientist, and by Philip Miller, the director of the Chelsea Physic Garden, in papers presented to the Royal Society of London. Treiwald explained his findings neatly in the title of his paper: 'An Account of Tulips and Other Bulbous Plants, Flowering Much Sooner, when their Bulbs are Placed on Bottles Filled with Water, than when Planted in the Ground.' He claimed that the bulbs would bloom five months earlier by this method, and his findings were confirmed by Miller. Using Thames water and plain glass carafes, Miller found that hyacinths were the most biddable of the bulbs, blooming before tulips and narcissi. He therefore recommended them as 'an amusement for display in the chambers of those without a garden'.

Although the sight of the development of roots through glass was always a source of fascination, especially for budding gardeners in the schoolroom, containers were also made in delftware. In his *Traité sur la jacinte*, published in 1773, George Voorhelm, grandson of the pioneering Peter, illustrated both a water-filled glass carafe and an earth-filled delftware pot, suitable for display on a windowsill or a mantelpiece. The idea of such containers in both earthenware and porcelain were developed by entrepreneurs with an eye on the market. Josiah Wedgwood offered faces or flower horns that might be hung on the wall, while the famous French factory at Sèvres produced a bewildering series of vases and flower pots for the top end of the market: some of these can be seen in the collection of the Rothschild family at Waddesdon Manor in Buckinghamshire.

The hyacinth 'Prince Albert Victor' from *Florist and Pomologist*, 1867, exhibiting the round, bottle-brush shape that represented the ideal for Victorian gardeners. The accompanying text describes the hyacinth as 'essentially a domestic plant, a pet plant which may be acquired at a trifling cost', which could appeal to all classes of society, from the Queen to the cottager. Although this reproduction has been coloured blue, it is described as dark red, and much superior to the feeble spikes and small crumpled bells of previous hyacinths.

RSL: *Florist and Pomologist*, 1867, opp. p.189 (Per.19185 d.62)

The fashion in colour changed at the end of the eighteenth century. A yellow hyacinth was developed, and Mrs Delany recorded how she was given a bloom called 'Ophir' by Lord Harcourt in 1780. From this, she made one of her exquisite mosaics from cut paper, a sort of *hortus siccus*, now in the British Museum. The poet John Clare, a keen naturalist, also mentions growing 'Ophir' in his garden in his diary for 1825.

In the nineteenth century darker colours were also coming into vogue. The horticulturalist William Paul inherited his father's nursery at Cheshunt in Hertfordshire before moving to Waltham Cross. Although best known as a rosarian, he worked on the development of all kinds of plants, including hyacinths. One of his famous varieties was 'Prince Albert Victor', acclaimed as a breakthrough with its deep reds and purples. At this period, too, the pyramidal shape so popular in the eighteenth century was being replaced by the cylindrical column that is the norm today.

The hyacinth, of course, is still wonderful for indoors display, providing both colour and scent in mid-winter. In gardens, it usually plays a part in mixed plantings of flowering bulbs, as in the Lime Walk at Sissinghurst Castle in Kent (p. 88). At Anglesey Abbey in Cambridgeshire, however, a whole garden is given over each spring to an extravagant display of hyacinths, 4,000 scented white 'Carnegie' and 'Blue Star', with a statue of Old Father Time rising eerily above the sea of blossoms.

PHILIP MILLER

Philip Miller, one of the most influential British gardeners of the eighteenth century, was born in Deptford in 1691, son of a market gardener. In 1722 he was appointed director of the Chelsea Physic Garden of the Society of Apothecaries by the garden's benefactor, Sir Hans Sloane. Here Miller presided for nearly half a century, making good use of his wide circle of correspondents to introduce new plants into the garden: from 1755 to 1760, for instance, he was in constant communication across the Atlantic with John Bartram in Philadelphia.

Early in his time at Chelsea, Miller was asked by Stephen Switzer to compile a small dictionary of gardening. Switzer was sometimes in charge of the famous Brompton Nursery when Henry Wise was absent obtaining plants, and although an authority on the theory of gardening, he lacked hands-on experience. Miller's *Gardener's Dictionary* was first published in 1724, with the endorsement of ten of London's leading nurserymen, including Thomas Fairchild of Hoxton and Robert Furber of Kensington Gore. The book proved an enormous success, and Miller went on producing new editions over the ensuing years. After a stormy relationship with Carl Linnaeus, who was notoriously difficult, Miller incorporated his new botanical classification in the seventh edition of the dictionary, published in 1759.

The *Gardener's Dictionary* was intended to be highly practical, and included only useful illustrations. As a complement, Miller produced from 1755 to 1760 a series of partworks of 'the most beautiful, useful and uncommon plants' described in the dictionary, illustrated in 300 copper-plate engravings. These were then gathered into one publication, *Figures of Plants*, published in 1771. The great botanical artist, Georg Ehret, who was related to Philip Miller by marriage, contributed sixteen plates, although the hyacinth shown here, looking remarkably like a larkspur, was drawn and engraved by J. S. Miller. Similar in colouring and style to Voorhelm's famous 'Koning van Groot Britanien', it was described by Miller as an 'Eastern Hyacinth and very double white Flower, whose inside is elegantly variegated with a Rose and purple colour'.

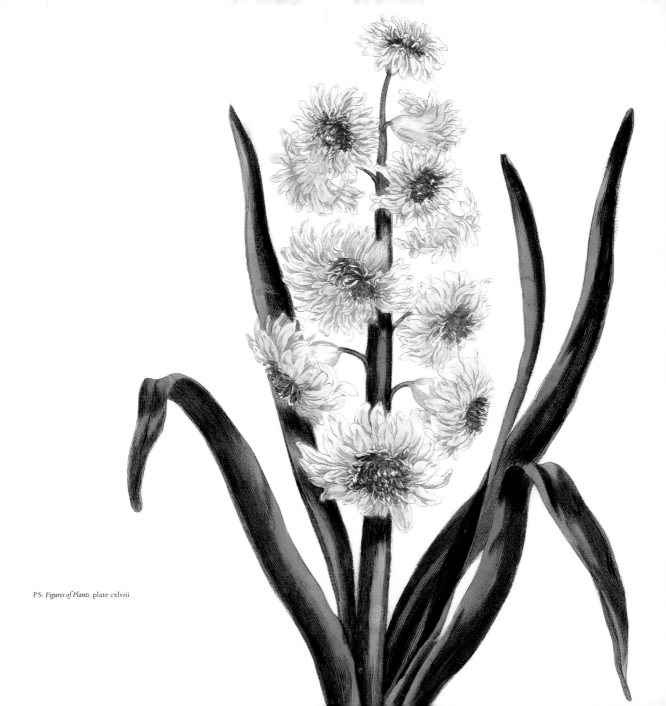

PS: *Figures of Plants*, plate cxlviii

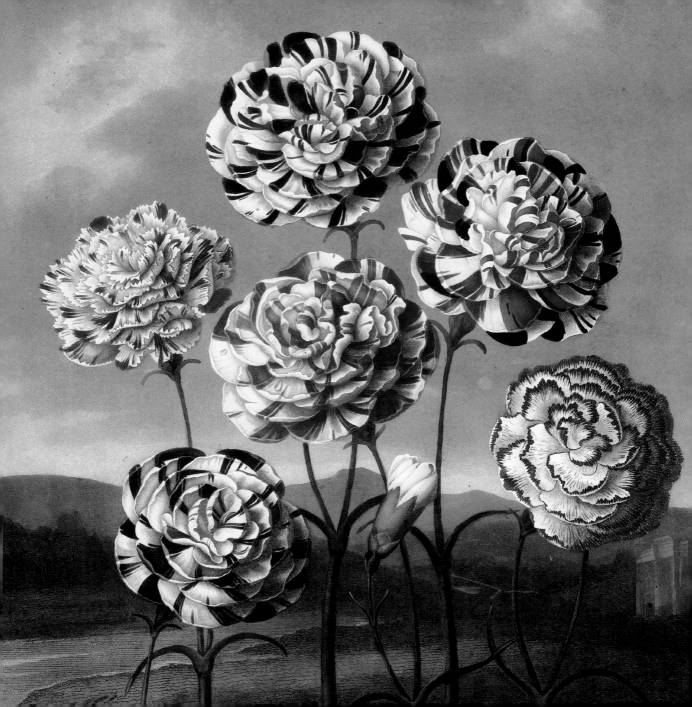

The Carnation

M embers of the Dianthus family – the carnation, the pink, and the Sweet William – are perhaps rather modest flowers. They do not have the regal mien of the rose or the lily, nor the dramatic traits of the tulip and the auricula. Yet, their delicate beauty and wonderful scent have captivated men and women over the centuries, and they are firmly woven into the warp and weft of our social history.

In Christian iconography, the carnation is associated with Christ's Passion, some say from Mary's tears at the Crucifixion, others from the similarity between the buds and nails. The flower is also the symbol of marriage, and for engagement portraits the sitters would be shown holding a carnation or a pink. In Joris Hoefnagel's painting of a Tudor marriage feast in Bermondsey, now in Hatfield House in Hertfordshire, one of the bridal attendants is shown carrying a floral arrangement of rosemary and pinks to be placed on the table for the wedding breakfast.

The term 'pink' at first referred to the fact that the flowers had scalloped or serrated edges to the petals. The original colour referred to as pink was in fact a yellow/green, and it was not until the early eighteenth century that a rosy hue, named after the flower, was adopted. Carnation, meanwhile, denoted a flesh colour, much sought after by the rich and famous: Queen Elizabeth I's favourite,

Robert Thornton's group of carnations in his *Temple of Flora*, 1807. The ideal for florists at this period was to achieve strong, almost geometric markings against a white background. The flowers with broad stripes of one colour were classed by florists as Flakes, here represented by 'Palmer's Duchess' and 'Palmer's Defiance'; flowers with stripes of two or three colours were known as Bizarres, represented by 'Caustin's British Monarch' and 'Midwinter's Duchess of Wurtemberg'; and those with petals that are tooth edged and tinged with colour as Picotees, represented by 'Davey's Defiance' and 'Princess of Wales'.

PS: *Temple of Flora*

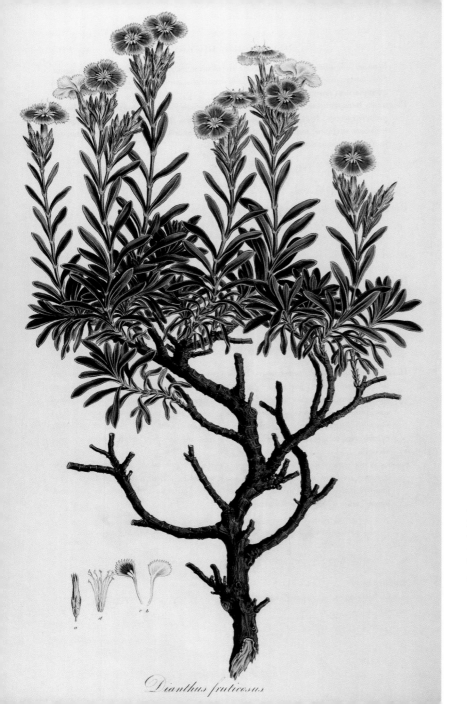

Dianthus fructicosus

Dianthus fructicosus, a drawing in coloured pencil made by Ferdinand Bauer after his expedition with John Sibthorp in 1786–7 to collect plants for the *Flora Graeca* (p. 66). This flower was found growing in profusion in the Aegean Islands.

PS: Ms. Sherard 241, fol.116

Robert Dudley, Earl of Leicester, commissioned in the 1570s bed furnishings of carnation silk embroidered with gold thread.

Britain had its own native members of the Dianthus family. John Parkinson in *Paradisi in Sole* recorded the Poole flower that grew upon rocks near Cogshot Castle on the Isle of Wight, while the Cheddar Pink (*Dianthus caesius*) was identified in the eighteenth century. But the first 'foreign' form to arrive in England was the Sweet William, *D.barbatus*, which came from Southern Europe *c.*1200. A similar journey was made by the pink, *D.plumarius*, but exactly when is uncertain. One theory is that they were brought over from the Continent by monks, who liked to flavour their wine with the strongly spiced variety; a theory supported by the fact that pinks are often found growing around the ruins of abbeys and other monastic properties. Geoffrey Chaucer, in his *Canterbury Tales*, written in the late 1380s, described how the Franklin enjoyed a mid-morning snack of a sop in wine; Sops in Wine is one of the flower's alternative names. Another is gillyflower, from *gilofre*, the spice clove that also happens to be a distant cousin. The names Sops in Wine and gillyflower have sometimes been applied to the carnation, *D.caryophyllus*, which was a species native to south and west France. In this form, it consisted of five small red petals and failed to excite. However, the form cultivated and developed in Persian and Ottoman gardens made a huge impact when it appeared in Western Europe via Moorish Spain, first recorded in Valencia in 1460. To confuse matters even more, the term gillyflower could also be applied to stocks and wallflowers, so that writers in the seventeenth century clarified the situation by calling pinks and carnations Julyflowers, the month when they were in bloom.

John Parkinson's solution to the dilemma was to have one chapter in which he featured carnations and gillyflowers, another for pinks, and yet another for Sweet Williams, which he also called Sweet Johns and armerias. He warned that the number of varieties was so great that to give general descriptions to them all would be never-ending. Of carnations and gillyflowers he recorded forty-seven varieties. By

the time John Rea was listing his carnations there were over 360, and in the early eighteenth century over 1,000 could be obtained. The wonderful variability that gardeners found in the carnation made this, along with the auricula, *the* florist's flower of seventeenth-century England.

The term 'florist' is first found in 1623 when Sir Henry Wootton referred to making the acquaintance of 'some excellent Florists (as they are stiled)'. Half a century later, Samuel Gilbert, in his *Florists' Vade Mecum* talked of the 'trifles adored amongst country women, but of no esteem', as opposed to the flowers of the florist 'who is taken up with things of more value'. Carl Linnaeus was to take a very different view in the next century. The multi-coloured and double varieties of flowers developed by florists he termed 'monsters', inveighing against the pompous names attached to them, and warning: 'These men cultivate a science peculiar to themselves, the mysteries of which are only known to the adepts: nor can knowledge be worth the attention of the botanist: *whereof let no sound botanist ever enter their societies.*'

This disdain conveys the conflict that could exist between botanists, who prided themselves on their scientific knowledge, and enthusiastic amateurs and practical gardeners, just as conflict existed between apothecaries and physicians. He was also voicing a certain element of social snobbery, although florists could be drawn from all levels of society. One of the early carnation enthusiasts was Ralph Tuggie, who opened a nursery in Westminster in 1620: two of his gillyflowers, 'Princess' and 'Rose gillyvor', were recorded by Parkinson.

The gentleman gardener Sir Thomas Hanmer grew all manner of florists' flowers in his Welsh garden of Bettisfield, including carnations. He may well be the source of a reference in a poem by Matthew Stevenson, included in a book, *Poems upon Several Occasions*, published in 1645 and now in the Bodleian Library. The poem names several varieties of carnation, and also talks of

> The Spanish, French and Welch infants
> We commend for their unmatch't variety.

The infants are probably seedlings, new varieties being brought in from the Spanish Netherlands, though the mention of Wales would seem to point to Hanmer. Several carnations that appear in the poem are mentioned by Hanmer in his *Garden Book* of 1659, including 'Grey Halo' – which he calls a 'murrey', indicating that it is purple-red – and 'Philomell or the Nightingale' described as 'grideline', a grey-purple. Although the poem talks of 'Welch infants', Hanmer found it difficult to raise carnations at Bettisfield. In a letter of 21 August 1671 to the diarist John Evelyn, he explained:

> I thought once to have ventur'd some gillyflowers, having two years since raised some very good ones from seed (which I never did before, not I thinke never shall againe, because the wett of England hinders the ripening of the seed more than in Holland and Flanders) but there is such a store of excellent ones all about London that I had not the confidence to adventure any to your view.

Stevenson's poem is entitled 'At the Florists Feast in Norwich. Flora wearing a Crown', and mentions cups, carousing, and beer. Florists' feasts became an integral part of the shows held by florists' societies, where gardeners took part in competitions with their fellow enthusiasts. Usually there was an auricula feast at any time between late March and early May, and a carnation feast in late July to mid-August. It may well be that if there was to be only one celebration, it was held to coincide with the show of carnations, when daylight was long and it could be hoped that the weather would be clement. Thus the *Norwich Gazette* for 1707 announced 'The Florists Feast or Entertainment for lovers of Flowers and Gardens will be kept at Mr Thomas Riggs . . . on Tuesday the 8th day of July next.'

With the development of varieties of carnations, subdivisions of classes began to appear at shows to provide a benchmark for the judges. As with the tulip, one division was for Bizarres, for flowers that were striped or variegated with three or four different shades of colour. Flakes were for two colours only, with large stripes, Painted Ladies for petals that were red or purple on the upper part, with clear white underneath. Last came Piquettes, also known as Picotees, where the ground was white or yellow, edge toothed or pounced (spotted) with red, scarlet, or purple.

It was with two members of the Dianthus family that Thomas Fairchild made botanical history at the beginning of the eighteenth century. The 'curious' Mr Fairchild – curious here being used in the sense of an enquiring nature – owned one of the leading London nurseries, based in Hoxton, just to the north-east of the City. Scientists had been feeling their way towards the idea that plants, like animals, had a sexuality. With the recently invented microscope, the Italian Marcello Malpighi and the Englishman Nehemiah Grew began to identify organs through which fertilization might occur. But it was the man on the ground who made the practical breakthrough. Fairchild reported that at a spot in his Hoxton nursery where the seeds of a carnation and a Sweet William had been scattered accidentally, the pollen of one entered the stigma of the other, producing a plant of a 'middle nature' that was 'barren like a mule or other mongrel animals which are generated from different species'. The result became known as 'Fairchild's Mule' and, reproduced through cuttings, was popular amongst gardeners. Another version of the story is that Fairchild deliberately impregnated the carnation, but he suppressed this version, for he could have been accused of tampering with God's work. At his death in October 1729, he bequeathed to his parish church £25 for the preaching of an annual sermon on 'the wonderful works of God in the creation', thus signifying that mankind would never have been able to produce a new species. This sermon is still preached in St Giles Cripplegate, the church of the Worshipful Company of Gardeners.

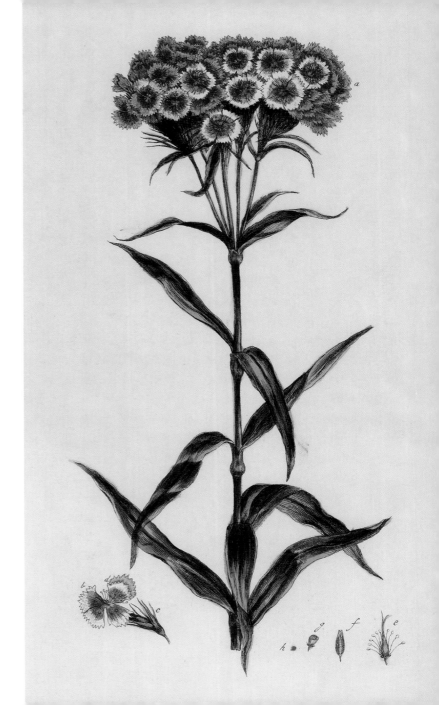

A Painted Lady Sweet William from
Philip Miller's *Figures of Plants*, 1771.
Miller describes them as 'one of the
most elegant Flowers of this Tribe',
advising that with their height and
deep-coloured flowers, they were 'very
proper Ornaments for large rural Walks
or to intermix with Shrubs'.

PS: *Figures of Plants*, plate cxxii

Fairchild was a member of the Company, and a rather militant one, for he disliked the way they were denied privileges accorded to the medieval livery companies. He also became a leading member of the Society of Gardeners, but could not be accepted into the Royal Society because of his practical rather than intellectual education. When, therefore, Fairchild's Mule was presented to the fellows of the Royal Society, he was present but his paper was read by another. Two pressed examples of the Mule survive: one, with clustered flowers like a Sweet William, is in the Natural History Museum in London, while the second, looking like a carnation, is in the Plant Sciences Department in Oxford.

In the sixteenth and seventeenth centuries, carnations were often grown in pots and supported on small wicker frames, as seen in contemporary paintings and engravings. Florists would cultivate their flowers in narrow rectangular beds so that they could keep an eagle eye on their development. Hanmer recorded growing his at Bettisfield in formal beds as part of the parterre, as did Le Nôtre in his gardens for Louis XIV. But in the eighteenth century carnations began to appear in shrubberies, alongside primroses, violets, and jasmine. The idea that the vogue for landscape gardening banished flowering beds completely from the scene is a false one, as Philip Miller makes clear in the 1731 edition of his *Gardener's Dictionary*. Under the entry for 'Wilderness' he writes:

> In those parts which are planted with deciduous Trees, may be planted next the Walks or Openings, Roses, Honeysuckles, Spirea frutex, and other kinds of low flowering shrubs which may be always kept very dwarf, and may be planted pretty close together; and at the foot of them at the side of the Walks may be planted Primroses, Violets, Daffodils, and many other sorts of Wood Flowers.

Fashionable pinks in the fifth volume of Joseph Harrison's *Floricultural Cabinet* for 1837. The flower shown at the top, 'Ibbett's Triumphant', is a laced pink, with dark, almost black edging to the petals. The two flowers reproduced below are Picotees, 'Wood's Superb' and 'Wood's Duke of Manchester'.

PS: *Floricultural Cabinet*, vol. 5 (1837), opp. p.25

Ibbetts Triumphant

Woods superb Pink

Woods Duke of Manchester Picotee

J. & J. Parkin.

Floricultural Cabinet.

Miller's suggestion was taken up by Philip Southcote at his garden at Woburn Farm in Surrey. Here he created from 1735 what has been described as a *ferme ornée*, with a peripheral walk planted with trees, shrubs, and flowers. A surviving plan drawn by Joseph Spence indicates a hedgerow providing a backing to the bed, next a 'plantation' of small trees and climbing plants such as honeysuckle, sweetbriar, and roses, and in front of these a mass of flowering plants graduating in height. Among these flowers are carnations and Sweet Williams, with an edging of pinks spilling onto the path.

At the end of the eighteenth century the pink joined the carnation as a florist's flower, and for this the ideal was a laced flower. The first example was 'Lady Stoverdale', a black-and-white variety raised in 1772 by James Maddock. This had rounded edges to the flower, rather than the traditional serrated petal. Twenty years later, in his *Florist's Directory*, James Maddock illustrated a double-flowered example with a dark eye and lacing close to the edge of each petal, along with much fringing. The *Account of Flower Shews* published in 1826 reported nineteen pink shows, with three classes being observed: purple-laced, red-laced, and black and white.

One noted area for both pinks and carnations was Oxford and its environs, but another great centre for pinks in particular was Paisley in Scotland. The cotton manufacturers Coats built their mills in the town and wove shawls in traditional patterns from Kashmir, brought back by soldiers serving in the East India Company. Their workers founded their Florists' Club in 1782, and proved great raisers of laced pinks, which are also known as Scotch Pinks as a result. A unique feature of this club was that members decided each winter to cultivate a particular kind of pink for the coming season and were expected to grow that chosen plant. In 1813, for instance, a snuff mill was awarded to Archibald Duncan for the twelve best pinks. This was a flourishing time for Paisley, both for the growing of pinks and of the manufacture of shawls, but the introduction of the jacquard machine was to put paid to the handlooms,

while the pollution from the factory chimneys of the Industrial Revolution created increasingly adverse growing conditions for the florists.

The mid-nineteenth century in Britain was a period of great wealth and of great poverty, as highlighted by Benjamin Disraeli in his novel, *Sybil, or The Two Nations*, published in 1845. In the Dianthus world, this can be illustrated by the development of the 'Malmaison' carnation. First raised in France during the Second Empire, it was named after 'Souvenir de la Malmaison' because its rich full flower looked like the Bourbon rose. The head gardener of a wealthy establishment might rise at first light to select a prize specimen from his hot-house to adorn the breakfast tray of the lady of the house. At the other end of the spectrum was the hated workhouse, the last refuge of the desperately poor. It was the master of the workhouse at Slough in Berkshire who raised 'Mrs Sinkins'. Named after his wife, this famous old-fashioned pink with its white ragged flowers shares with the 'Malmaison' carnation a wonderfully strong scent.

JOHN PARKINSON

John Parkinson is described as Britain's most influential gardener of the seventeenth century, with Philip Miller occupying this position for the eighteenth century. Parkinson came to horticulture through his training as an apothecary and herbalist. He served his apprenticeship with a member of the Grocers' Company of London, but felt that the work of apothecaries was insufficiently recognized within the Company, and supported those who wished to form a separate organization. In 1617, when the Society of Apothecaries was established, he became a member of its first court of assistants. Such was the respect for his work, that he was consulted by the College of Physicians during the compilation of their first *Pharmacopoeia Londiniensis*.

In his garden in Long Acre he cultivated plants from all over the known world, such as Marvels of Peru and *Tradescantia virginiana*. His interest in the latest developments in horticulture are shown by the plants that he recorded in his first book, *Paradisi in Sole, paradisus terrestris*, published in 1629. The book was dedicated to Queen Henrietta Maria, and in return Charles I gave him the title, Botanicus Regius Primarius. Many of the plants described, such as the auriculas, the tulips, and the carnations and pinks had been greatly developed in the short period since their introduction into Western European gardens. The page reproduced here shows some of the carnations, including two tawnies raised by the Westminster nurseryman, Ralph Tuggie: his 'Princess' (no. 1) and 'Rose Gillyvor' (no. 12).

Like many botanists in this period, Parkinson was frustrated at the variety of names given to plants, and as an apothecary he was concerned about mistaken attributions and deliberate passing off that could make the remedies dangerous for patients. In his second book, *Theatrum botanicum*, published in 1640, he described nearly 4,000 plants, dividing them into seventeen 'tribes' based partly on their medicinal qualities and partly on habitat.

Paradisi in Sole, p.313, Bodleian Antiq.
c. E. 1629

I.

Helleborus niger legi
timus.

III.
Leucoium bulbosum triphyll
Minus.

II.
Leucoium bulbosum triphyl
Maius Byzantinum:

V.
Leucoium bulbosum hexaphyllon
Minus.

IIII.
Leucoium bulbosum hexaphyll
Maius

The Snowdrop

Through the centuries poets have celebrated the appearance of the snowdrop, often pushing bravely through the snow to herald the coming of spring. The Roman poet Columella likened them to stars brought down from heaven, while in the nineteenth century Christina Rossetti wrote:

> I've brought some snowdrops; only just a few
> But quite enough to prove the world awake.

Although the snowdrop seems as British as the primrose and the daffodil, its status as a native is a bone of contention among botanists, just one of the many mysteries that surround it. Another is its naming. In his *De historia stirpium* published in 1542, Leonhart Fuchs puts a plant that looks exactly like a snowdrop in the section on violets, calling it 'viola alba'. A century later John Rea in his *Flora* talks of bulbous violets that flower in February and early March, the smaller of which is known vulgarly as snowflowers. The name 'snowdrop' begins to appear at the end of the seventeenth century, drawn from the German *Schneetropfen*, pendants or ear-drops, fashionable adornments of that period.

Basil Besler in his massive work, *Hortus Eysttetensis* arranged his flowers according to season. At the very end, he illustrates twenty-eight plants that could withstand freezing. One page shows the hellebore known as the Christmas Rose, surrounded by four flowers that he has captioned as leocociums. Two

Page of winter flowers from Basil Besler's *Hortus Eysttetensis*, 1613. The two 'leocoiums' at the top are now known as snowdrops, the two at the bottom as snowflakes. In Besler's time *leocoium* was a 'catch-all' of a group, where various assorted plants were placed.

PS: *Hortus Eysttetensis*, Primus Ordo Classis Hyberna, fol. 1 (Sherard 618)

VIOLA ALBA

Hornungßblům.
(white violet)

are snowdrops and two are what are now called snowflakes, thus bringing in yet another of the mysteries. When is a snowdrop a snowdrop, and when is it a snowflake? Linnaeus sorted this out when he named the snowdrop *Galanthus nivalis*, from the Greek *gala* for milk and *anthos*, flower, and *nivalis*, meaning 'of winter'. The snowflake, which looks very like the snowdrop, though they have essential differences in the forms of the perianth and anther, Linnaeus called *Leocoium aestivum*, thus indicating it is a flower of the summer, although Besler had thought otherwise. After Linnaeus we are on fairly sure ground,

Leonhart Fuchs, along with other botanical writers of the sixteenth century, thought that the snowdrop was a form of viola because it had a sweet smell like a violet's. It is shown as 'viola alba' in his *De historia stirpium*, published in 1542.

PS: *De historia stirpium*, p.486 (Sherard 646)

Galanthus nivalis in William Curtis's *Flora Londinensis*. Curtis believed that this was not a native plant but escaped from a garden. His first record was of one found by Mr Ballard at the foot of the Malvern Hills, where no traces were perceptible either of buildings or gardens.

PS: *Flora Londinensis*, vol. 2 (1835)

Galanthus nivalis

but there is no doubt that the snowdrop and snowflake had previously been confused with each other. Even their local names in different parts of Britain are similar. The snowdrop has names such as Candlemas Bells (Candlemas was celebrated on 2 February), Death's Flower, Dew Drops, Eve's Tears, Naked Maidens, and White Queen. Death's Flower is a reminder that the snowdrop was in the eighteenth and nineteenth centuries a symbol of death, and it was considered bad luck to carry the blooms into the house. The snowflake was known as the Mountain Snowdrop and the Summer Snowdrop, as well as Loddon Lily, a reference to a tributary of the Thames.

To return to the tricky question of the snowdrop's origins. Many varieties originate from Eastern Europe and Turkey, as indicated by Besler's reference to a 'Leocoium Byzantinum'. Snowdrops growing wild in England were first recorded in the 1770s in Gloucestershire and Worcestershire. One site where wild snowdrops can still be seen growing in abundance is in the grounds of Thrumpton Hall in the valley of the Trent south of Nottingham. This land was once a substantial Roman settlement, and one theory is that the Romans introduced the snowdrop into Britain.

The snowflake, meanwhile, was recorded by William Curtis in his *Flora Londinensis*, where he describes them as 'undoubtedly wild', flowering just above the high-water mark of the Thames between Greenwich and Woolwich and on the Isle of Dogs at some point before his publication of 1788. As the flower looked so like the snowdrop, he coined the new English name of snowflake. Just as the *Fritillaria meleagris* might have grown quietly over the centuries in English meadows without being spotted by botanists (p. 69), Curtis wonders at the possibility that such an ornamental plant as the snowflake, growing in a public place, could have escaped 'the prying eyes of the many Botanists who have resided in London for such a length of time'. The mystery remains.

The modest dimensions of the snowdrop and its early flowering made it an unlikely candidate for the great seventeenth-century flower paintings. The snowflake does make an appearance, however, as in Bosschaert's picture. As it can grow up to a metre in height, it was often used to crown an arrangement, along with tulips and irises. The great house of the Sackville family, Knole in Kent, boasts no fewer than three long galleries. In one of these, the Cartoon Gallery, a series of flower paintings were set high up on the walls, like a frieze, divided by arcading in the first years of the seventeenth century. In wet weather, long galleries would be used for recreation, so that the flower-pieces acted as a substitute for walks in the garden. Among the paintings is an arrangement of snowflakes and white lilies in a majolica vase.

When Philip Southcote designed his *ferme ornée* at Woburn in Surrey in the early eighteenth century, his meandering walk was planted with trees, shrubs, and flowers, as described on p. 112. In 1752 one of his friends, Joseph Spence, reproduced a rough layout of the planting showing that snowdrops were grown alongside crocuses, jonquils, and primroses in the front of the borders. Southcote was aiming for interest in colour and texture throughout the year, and the snowdrops would have provided this at a fallow time for other plants.

This is a very early example of using 'wild' flowers in a garden context. William Robinson, of course, is famous for creating wild gardens. Legend has it that he was so infuriated by having to arrange bedding plants in formal rows and patterns – the horticultural fashion of the mid-Victorian period – that he quarrelled with his employers at Ballykilcavan in Ireland, put out the fires in the greenhouses, opened the windows to the cold winter air, and left. Ten years later, he turned from militant activism to advocacy with the pen. In *The Wild Garden*, published in 1871, he attacked the formal artificiality, proposing instead the planting of native and wild flowers. Rather than 'bedding out', which requires

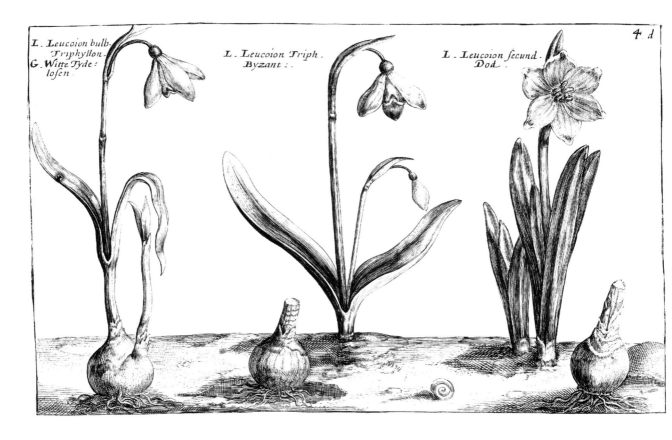

L. *Leucoion bulb.*
Triphyllon.
G. *Witte Tyde:*
losen

L. *Leucoion Triph.*
Byzant:.

L. *Leucoion secund.*
Dod.

4.d

Snowdrops in Crispijn de Passe's *Hortus Floridus*, published in Arnhem in 1614. Two of the plants, described by de Passe as *Leocoium triphyllon*, are indeed snowdrops, but the flower on the right, which he derived from Dodoens, remains a mystery.

Hortus Floridus, tab 4d, Bodleian Vet.B2.c.1

endless care, he suggests that spring-flowering bulbs such as the snowdrop should be planted in belts of grass or around shrubberies, and that the mowing of grass, which the current fashion dictated should be undertaken every fortnight, should be abandoned. 'We want shaven carpets of grass here and there, but what nonsense it is to shave it as often as foolish men shave their faces!'

Robinson's *Wild Garden* coincided with a spurt of interest in the snowdrop, with new species being introduced from Eastern and Southern Europe. From Italy came the *Galanthus atkinsii*, which is named after a Northamptonshire nurseryman, James Atkins, who retired to Painswick in Gloucestershire and as a galanthophile, a lover of snowdrops, devoted himself to their cultivation. Painswick still provides a spectacular display of the flowers. From the Caucasus came *G.elwesii*, which was named after the botanist, H. J. Elwes, who found it near Smyrna in 1874. Some of these exotic snowdrops are to be seen at Anglesey Abbey in Cambridgeshire. The former head gardener, Richard Ayres, and fellow galanthophile, John Sales, former chief gardens adviser at the National Trust, developed the cultivation of the Anglesey snowdrops, including some hybrids that were discovered on the rubbish tip that had served the Victorian garden. Anglesey Abbey is annually open at weekends so that visitors may enjoy the magnificent display — these weekends getting earlier in the calendar with milder winters.

A. H. CHURCH

Arthur Harry Church was born in Plymouth in 1865, the son of a saddlery foreman. When he received a small inheritance on the death of his mother, he was able to attend Aberystwyth University, which offered external London degrees. In 1891 he became a postgraduate student at Jesus College, Oxford, which had strong links with Wales. Church was a very good teacher of botany, but his lack of funds meant that he had little opportunity to travel, and instead found pleasure and solace in his analysis of plants and detailed drawings of them.

His book of 1908, *Types of Floral Mechanism*, reflects his view that botanical illustrations should not be decorative additions, but show plants as machines, ensuring successful sexual reproduction. His idea was to consider the 'best' 100 flowers, but he fell out with the Oxford University Press and most of his work was never published.

The *G.nivalis* illustrated here is sometimes known as subsp. 'Imperati', and is a local variant from Italy. Notable for its large flowers, this snowdrop commemorates a late sixteenth-century Neapolitan apothecary, Ferrante Imperato.

PS: *Types of Floral Mechanism*, opp. p.17

The Rose

O f all flowers, the rose is probably the closest to the hearts of the British, coming top in the poll conducted a few years back and referred to in the introduction. Along with the red cross of St George it is the national symbol of England. It was fashionable until recently to describe the epitome of female beauty as an English rose, while the perfect rural idyll was a cottage with roses growing around the door.

Yet this is not just a British love affair, nor is it a recent phenomenon. For the ancient Greeks the rose was the symbol of love, sacred to the goddess Aphrodite, whose Roman equivalent was Venus. According to myth, when the goddess was born out of sea foam, there also emerged a thorny bush, which when watered by the nectar of gods blossomed with white roses. This is the legend that Botticelli depicted in his famous painting, *The Birth of Venus*. The Greeks thought that originally all roses were white but were stained red by the blood of the beautiful youth, Adonis, when he was killed by a wild boar. Another version has it that Aphrodite, in love with Adonis, turned roses red with the blood from her foot cut by thorns as she rushed to his assistance.

The great Greek botanist Theophrastus in his *Enquiry into Plants*, written in the third century BC, describes roses in detail: 'Most have five petals – but some have twelve or twenty, and some a great many more than these: for there are some they say which are even called hundred petalled . . . most of such roses grow near Philippi . . . most sweet scented of all are the roses of Cyrene.' The reference to the multi-petalled variety would suggest that wild species were already being modified through cultivation.

The Gallica rose, one of the four varieties cultivated in Britain since the Middle Ages. This illustration is from Redouté's *Les Roses* (see p. 143).

The beauty of roses attracted the hedonistic Romans, but above all they valued their heady scent. The flowers were grown in gardens and on a large scale in centres such as Paestum in southern Italy, for the production of oil. Petals would be strewn at feasts, but the rose also played another role at the dining table. According to an anonymous Latin poet:

> The rose is the flower of Venus:
> in order that her sweet thefts might be concealed.
> Love dedicated to Harpocrates, the God of Silence,
> this gift of his mother.
> Hence the host hangs over his friendly table a rose,
> that the guests underneath it may know how to keep silence as to what is said.

This is the source of the term 'sub rosa'; and the origin of the Victorian plaster rose in the centre of a ceiling.

For the Romans, roses had a funerary connotation, with Rosalia as a ceremony associated with the cult of the dead. Christian tradition possibly assimilated this connection when the rose with thorns became the image of the five wounds of Christ and the torment of martyrs. But above all, the flower was associated with the Virgin Mary, the rose without thorns because she was untouched by Original Sin. This is recollected in the medieval carol, 'There is no Rose of Such Virtue as is the Rose that Bore Jesus'. The flower is often shown or alluded to in paintings of the Virgin and Child, and in scenes of the Virgin's Assumption roses sprout alongside lilies inside her empty tomb. The term 'rosary', the string of beads used as a guide to devotion, also means rose garden, and sometimes the beads are made from dried rose petals.

In the eighth century, Charlemagne ordered
planting of roses and lilies on land controlled
by the Crown, because both flowers were
very important medically. He also imported
rose perfume from Persia where the oil of
attar had long been the most expensive of
marriage gifts. In the thirteenth century the
French established rose oil manufacture at
Provins, south-east of Paris: the town is still
famous for its production of all kinds of rose
confectionery, including a kind of petal jam.
John Gerard in his herbal of 1597 explained

The rose from Pierandrea Mattioli's *Commentarii* on the work
of Dioscorides. Mattioli was an Italian physician and botanist
who spent twenty years in Prague in the service of the
Archduke Ferdinand and the Emperor Maximilian II. His
first edition, produced in 1544, had no pictures, but these
were added in subsequent editions, reaching a peak with the
version published in Venice in 1565, as shown here. By using
large woodcuts from pearwood, Mattioli's artist, Giorgio
Liberale, was able to add shading to the flowers and foliage,
and to give the illustrations a fullness and liveliness lacking
in earlier illustrated herbals.

PS: *Commentarii*, p.185 (Sherard 655)

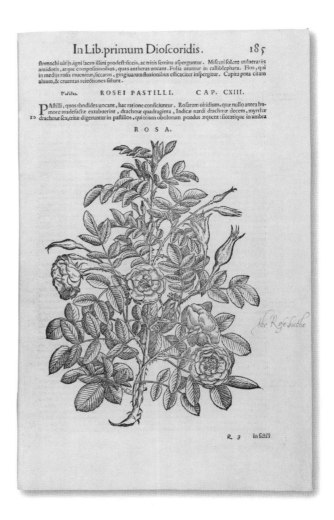

how roses were of value both for apothecaries and for cooks: 'The distilled water of Roses is good for the strengthening of the heart, and refreshing of the spirits, and likewise for all things that require gentle cooling. The same being put in junketing dishes, cakes, sauces, and many other pleasant things, giveth a fine and delectable taste.' He also mentioned how the flower is 'the honour and ornament of our English Sceptre', an idea given tangible form by the use of roses in coronation oil by monarchs from the time of Elizabeth I.

What were these roses? Today we are confronted with a huge, and bewildering, variety of different species and classifications, so it comes as rather a relief to find that by the end of the Middle Ages there were just four cultivated varieties, Alba, Gallica, Damask, and Centifolia, along with the wild *Rosa canina*. The reference to dog, as in dog Latin, denotes that it is common, and the sweetbriar from the *canina* group can be seen growing as a scrambler in hedgerows all over Britain. The Dog Rose has an arrangement of sepals that is different from all other roses, and can be remembered through an old riddle:

> On a summer's day in sultry weather
> Five brethren were born together
> Two had beards and two had none
> And the other had but half of one.

Sweetbriar or *Rosa canina*, a painting on vellum by Georg Dionysius Ehret. In 1750 the German artist took the post of gardener at the Botanic Garden in Oxford, but came up against the autocratic professor of botany, Humphrey Sibthorp, and resigned after only a year. A man of charm, Ehret was able to make a living by teaching the fashionable activity of botanizing, and providing exquisite flower images for members of the aristocracy. The sweetbriar is one of a collection of 140 paintings on vellum made for John Stuart, 3rd Earl of Bute, now in the Radcliffe Science Library in Oxford. Bute, a man of huge wealth with a great interest in floriculture, not only established the Royal Botanic Garden in Edinburgh but also was instrumental in developing the Royal Botanic Gardens at Kew through his close friendship with Princess Augusta, the mother of George III.
RSL: Ehret album, vol. 2, 5/132 (R.R.x.321)

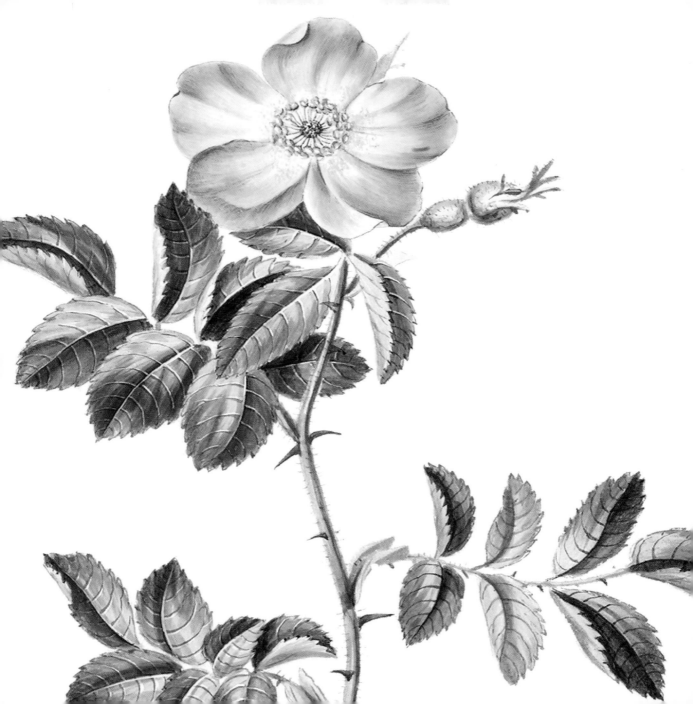

When Venus arises from the sea in Botticelli's painting, Alba Roses are depicted descending in showers. In his other famous painting, *La Primavera*, he shows red roses, which are probably Gallica, in a semi-double form. The name Gallica indicates how this rose grows naturally in France and in Southern Europe. It is the variety *officinalis*, which has been grown at Provins since the Middle Ages, and is also known as the Apothecary's Rose. The Damask is a close ally of the Gallicas, but with elongated hips rather than round. It too provides oil for herbal remedies. The Centifolia is a complex hybrid, possibly involving the other three varieties along with the Dog Rose. It is often called the Cabbage Rose because of the rich and heavy form of the flowers. A favourite of Dutch flower artists, it appears twice in Bosschaert's painting.

Roses are celebrated more than fifty times in the works of Shakespeare. Many are poetic references, but the playwright brings the rose centre stage in *Henry VI Part I, Act II, Scene 4*, written in 1590, when he has two opposing factions of the royal house of Plantagenet plucking flowers from bushes in the gardens of the Temple in London as a prelude to conflict. The red rose, the Gallica, was one of the heraldic badges of the house of Lancaster, while the white rose, the Alba, was worn by the house of York. This scene was almost certainly a figment of Shakespeare's imagination, while the name Wars of the Roses that was romantically bestowed upon the ensuing civil war was probably an invention by Sir Walter Scott. In his novel *Anne of Geierstein*, published in 1829, he referred to 'the civil discords so dreadfully prosecuted in the wars of the White and Red Roses'. Another myth is the naming of Rosa Mundi, a semi-double Gallica striped pink and white, which the Elizabethan chronicler, John Stow, attributed to the Fair Rosamund, a mistress of Henry II who was done to death by his jealous Queen, Eleanor of Aquitaine. The connections between royal history and the rose continue with the Tudor rose, symbol of the uniting of the Yorkists and Lancastrians when Henry Tudor married Elizabeth of York. In the eighteenth century, Jacobites rallied to the Old Pretender under the white rose, and – just to confuse matters thoroughly – George II's Lancashire Fusiliers wore white roses in their caps at the Battle of Minden in 1759.

Rosa alba from Elizabeth
Blackwell's *Curious Herbal*,
published in 1751.

PS: *Curious Herbal*, vol. 1, plate 73

Rofa Carolina fragrans,
folüs mediotenus ferratis.

Rofa Sanguiforbæ majoris
folio, fructu longo pendulo ex NA.

All these roses were red, white, or pink. Yellow roses began to appear in Europe in the 1580s with *R.foetida* , the 'yellow rose of Asia', followed in 1601 by *R.sulphurea* (now *R.hemisphaerica*) acquired by Clusius from Turkey via Strasbourg. However, these were not taken up with great enthusiasm until the end of the eighteenth century. One reason may be their lack of scent. Philip Miller, director of the Chelsea Physic Garden and an enthusiastic rose grower, criticized nurserymen who sold the yellow rose, which he called *R.lutea*, for large amounts of money for a flower that lasted a short time and had no scent.

Miller was particularly fond of Moss Roses, a subgroup of Centifolias produced through hybridization by Dutch breeders. They are distinguished by their resin-scented hair that cover the flower stalk and calyx. By growing them against the walls of his nursery, he was able to produce flowers in August and September. In the 1724 edition of his *Dictionary*, he listed twenty-nine varieties of rose that were available through London nurseries, along with more owned by the Duchess of Beaufort at her Gloucestershire estate, Badminton. Mary, Duchess of Beaufort, was an avid botanist and horticulturalist, whose aim it was to own as large a collection of cultivated plants as possible. Her successor in this endeavour was Josephine de Beauharnais, wife of Napoleon Bonaparte.

Rosa carolina and *Rosa sanguisorbae* from the *Hortus Elthamensis* compiled by the German botanist Johann Jakob Dillenius and published in 1732. The title of the book refers to the garden in Eltham created by James Sherard with the help of his brother William. The Sherards commissioned Dillenius to catalogue exotic and new introductions in the garden and, through lack of money, he also drew and engraved the illustrations, explaining in his preface, 'For my own part I am satisfied that I have taken every care to make them accurate.' However, Dillenius did not get on well with James Sherard and felt that his efforts were not properly appreciated.
PS: *Hortus Elthamensis*, plate ccxlv (Sherard 644)

In April 1799 Josephine bought the run-down estate of Malmaison, seven miles out of Paris. She proceeded to spend a fortune not only restoring the château and its grounds, but in seeking out flora and fauna from all over the world in her aim 'that Malmaison may soon become the source of riches for all [of France]'. In particular she established a rose garden to end all rose gardens, containing over 250 varieties, including many from her native island of Martinique.

Josephine created her rose garden at Malmaison at a time when new varieties of roses were arriving in Europe from India and China. Horticulturally minded sea captains brought back 'Slater's Crimson China' and 'Parson's Crimson China' in 1789, and the latter became one of the ancestors of new categories of roses developed in the nineteenth century. The names of some of these categories can be misleading: Noisettes were named not after nuts, but after the rose grower, Louis Noisette, while Bourbons commemorated the French island of Bourbon in the Indian Ocean rather than the French royal house restored to the throne after the fall of Bonaparte. In 1808 Sir Abraham Hume received from China the first tea-scented rose, 'Hume's Blush', and this was crossed with Noisettes and Bourbons to produce the Tea Rose. When Redouté produced *Les Roses* between 1817 and 1824, the roses illustrated were overwhelmingly red, pink, and white, with just a handful of yellow examples. However, as the century progressed, so the number of roses in hues of yellow, and later in orange and scarlet, proliferated as Chinese varieties were crossed with European to give longer periods of flowering. Hybrid Perpetuals came to dominate the nursery catalogue: the eminent nursery of Paul & Son in Cheshunt listed 538 Hybrid Perpetuals in 1872, and by the end of the century, there were more than 3,000 varieties offered across Europe and America. On the other hand, cultivars of the old roses – the Albas, Gallicas, Damasks, and Centifolia – numbered 292 in Paul's catalogue for 1840, but had declined to 51 by 1865, some lost forever.

Rosa chinensis (*Rosa indica*), from Ellen Willmott's
Genus Rosa, published between 1910 and 1914
with illustrations by the landscape painter Alfred
Parsons. *Rosa chinensis*, introduced to England from
central China by Sir Joseph Banks in 1789, was
described by Miss Willmott as the most popular
and widely grown rose in Europe at the beginning
of the twentieth century.

PS: *The Genus Rosa*, 26: Part V, 1911

New books came with the new varieties. For enthusiasts William Paul produced the *Rose Garden* in 1848, for the general reader Samuel Reynolds Hole, Dean of Rochester, wrote the *Book about Roses*, the first edition of which appeared in 1869. Hole was the founder of the National Rose Society and impresario of rose exhibitions, hailed 'the Rose King' by the Poet Laureate, Alfred Lord Tennyson.

The fickle finger of fashion, however, was on the move. As a student in the early 1860s at the National School of Art in South Kensington, Gertrude Jekyll admired the stems of wild roses that William Morris depicted on one of his first wallpaper designs, 'Trellis'. With the young architect Edwin Lutyens she explored the lanes of rural – and agriculturally depressed – Surrey to seek out ideal forms of old cultivars of roses and ramblers growing on walls and in cottage gardens. When she came to write *Roses for English Gardens* with the grower Gerard Mawley in 1902, she recommended the use of roses on pergolas, pillars, and arches, and scrambling over walls 'as fountains growing free . . . converting ugliness to beauty'.

Gradually the enthusiasm for what were termed Old Roses grew in strength and volubility. Sacheverell Sitwell, writing in the late 1930s, declared: 'Modern innovation has gone too far, where Roses are concerned, until it has been forgotten what is the meaning of the Rose.' Using her influence as the gardening correspondent of the *Observer*, Vita Sackville-West wrote in damning fashion that

A page of roses from the *Catalogus plantarum*, published in 1730 by the Society of Gardeners. The Society, founded in 1724 to protect the interests of nursery gardeners who were often accused of misleading patrons through the confusion that existed over the naming of plants, had a membership of twenty, including Thomas Fairchild, Robert Furber, and Philip Miller, and met at Newall's Coffee House in Chelsea, a convenient venue for the director of the Physic Garden. Originally the intent was to publish four volumes to provide an illustrated survey of new plant introductions, but in the event only one was produced. Miller took charge of the work, commissioning drawings from the distinguished botanical artist Jacob van Huysum.
PS: *Catalogus plantarum*, plate 18 (Sherard 685)

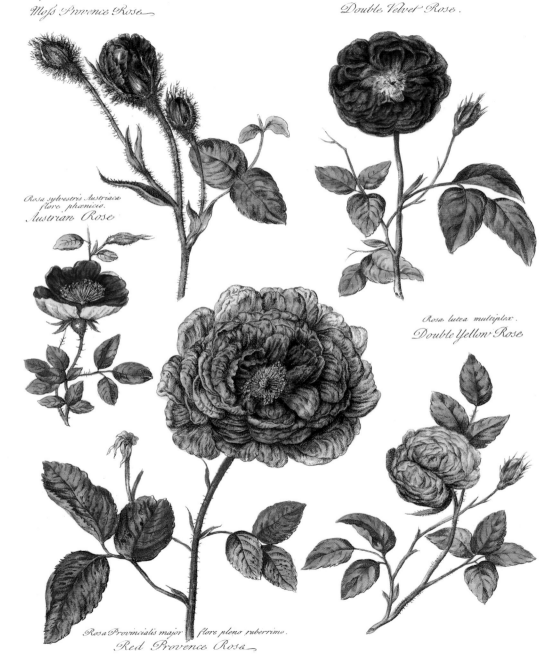

Rosa Provincialis spinosissima.
pedunculis muscoso.
Moss Provence Rose.

Rosa ex rubro-nigricante. flore pleno.
Double Velvet Rose.

Rosa sylvestris Austriaca
flore phœnicio.
Austrian Rose.

Rosa lutea multiplex.
Double Yellow Rose.

Rosa Provincialis major flore pleno ruberrimo.
Red Provence Rose.

'Conventionally-minded people remark that they like a rose to be a rose, by which they apparently mean an overblown pink, scarlet or yellow object, desirable enough in itself, but lacking the subtlety to be found in some of the traditional roses.' Graham Stuart Thomas from his base at Sunningdale Nurseries in Berkshire, toured England and Ireland, and used his contacts in Europe and America to rebuild stocks of old classes. In the United States, former colonial cemeteries turned out to be good hunting grounds for 'rose rustlers' seeking to recover lost varieties.

There are many rose gardens all over the world, but perhaps one of the finest is at Mottisfont Abbey in Hampshire. Here from 1972 Graham Stuart Thomas, who had become the National Trust's chief gardens adviser, worked with the head gardener David Stone to convert the former kitchen garden into a haven for Old Roses. Several were given to them by the group of dedicated enthusiasts who had rescued the endangered species. The Damask Rose 'Sissinghurst Castle' was found by Vita Sackville-West on the castle rubbish dump in 1930. The gardener Norah Lindsay provided the 'Rose de Resht', related to the Portland Roses and derived from the Damask, which she had brought back from Persia before the Second World War. Sacheverell Sitwell in Northamptonshire gave 'Maréchal Devoust', and from the Oxford Botanic Garden, Stuart Thomas obtained 'Francofurtana'. Every midsummer, visitors can enjoy all these and other varieties in the Walled Garden at Mottisfont: a brilliant pot pourri in scent and colour.

Detail of the rose from
Mattioli's commentaries
on Dioscorides (p.129)

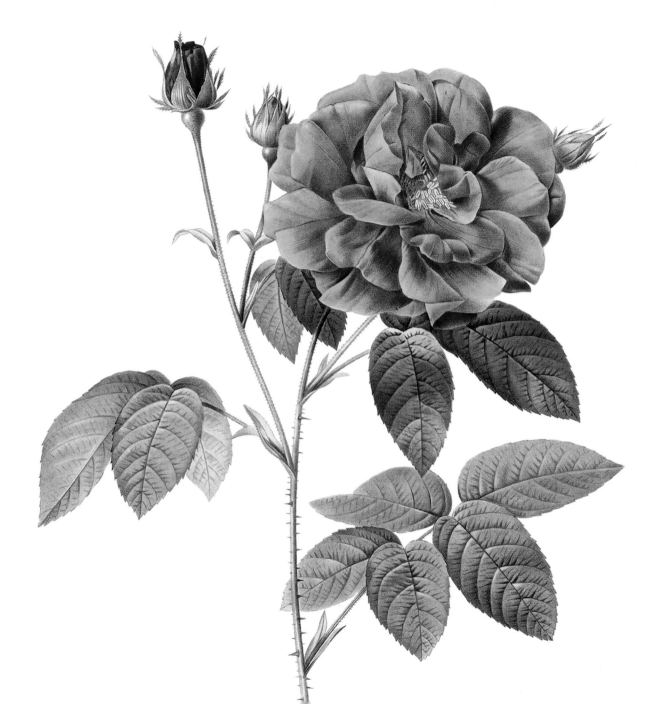

PIERRE-JOSEPH REDOUTÉ

Redouté was born into a family of painters in 1759 in the Belgian Ardennes. At the age of 23 he met in Paris a wealthy botanist and bibliophile, Charles Louis L'Heritier de Brutelle, who took him under his wing, inviting him to England where, working on plant illustrations at Kew, he learnt the technique of stipple engraving. Redouté painted flowers for Queen Marie Antoinette during her imprisonment in the Temple, and for the Empress Josephine Bonaparte, who became his enthusiastic patron. When Josephine set out to fill the gardens at Malmaison with the rarest plants that the Old and New Worlds could supply, she commissioned Redouté to paint them at a generous annual salary of 18,000 francs.

After completing his monumental work on the lily and lily-like plants, *Les Liliacées* (p. 20), he turned to the rose. *Les Roses* occupied him for a further seven years, and he produced three volumes, published between 1817 and 1824. By the time the first volume appeared, Josephine was dead, so it was dedicated instead to the Duchesse d'Orléans. Despite commanding high sums for his work, Redouté enjoyed a lavish lifestyle that eventually bankrupted him, so he sought to recover his fortunes by creating a huge flower painting that was never completed. On 19 June 1840 he suffered a stroke while examining a white lily, and died the following day. Wreaths of roses and lilies were laid on his coffin.

His skill with stipple engraving is shown in this illustration of a *Rosa gallica*, which was raised by van Eeden from Haarlem and introduced to Malmaison in 1810.

RSL: *Les Roses*, vol. 1, opp. p.73 (R.R.y.146)

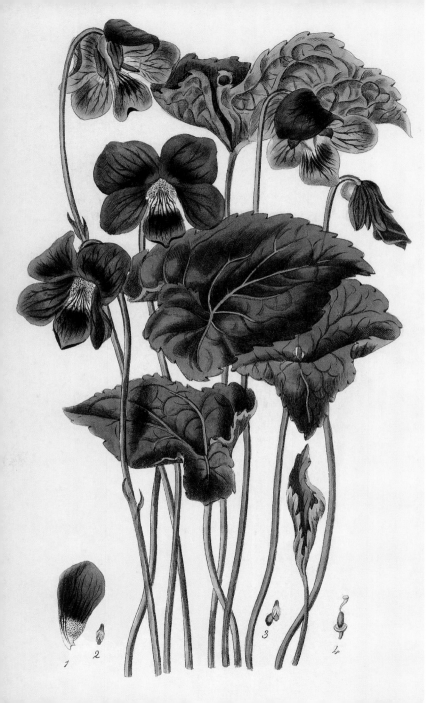

Viola cucullata, referred to by Robert Sweet in his *British Flower Garden*, 1835, as the hollow-leaved violet, although 'cucullate' is usually defined as shaped like a hood. He notes it as a 'very pretty violet . . . common throughout a great portion of the United States of America, delighting in wet places and in a clayey soil'. It was introduced into Britain in 1772.

PS: *British Flower Garden*, vol. 3, 2nd series (1835). p.298

The Violet and the Pansy

The Ancient Greeks attributed both sensual and sexual qualities to the violet. This modest flower was associated with Aphrodite, the goddess of love, and her son Priapus, deity of gardens and generation – one of the names for the violet was *priapeion*. This rather unlikely relationship was probably due to the strong scent of the flower, which begs the question: when Victorian ladies applied to themselves the fashionable perfume of Parma violets, did they know what moral dangers might ensue?

Christian iconography made quite different associations, characterizing the violet with its nodding head as an example of modesty and humility. The flower thus became the symbol both of the Virgin Mary and Christ, appearing in paintings of the Adoration, of the Madonna and Child, and occasionally, of the Crucifixion. However, it was the sensual association that dictated the appearance of violets in the tapestry series 'The Hunt of the Unicorn', probably woven for the marriage in 1514 of François, Count of Angoulême, who became King of France the following year. The tapestries are now displayed in the Cloisters in New York. In the last scene the captured unicorn lies tethered to the pomegranate tree of fertility, in a flowery mead of plants of sex – bistort, lords and ladies, the purple orchis, bluebells, and the sweet violet.

Violets were an important ingredient in medicine, regarded by doctors as cool, bland, and soothing. The oil of violets was recommended by the first-century Roman, Pliny the Elder, for headaches, by Anthony Askham in his *Lytel Herbal* of 1550 as a sedative, by Gerard in his 1597 *Herball* as a laxative, and by Nicholas Culpeper in his *English Physitian* of 1652 for the 'French pox'. The flowers were used in salads, and are still candied for confectionery.

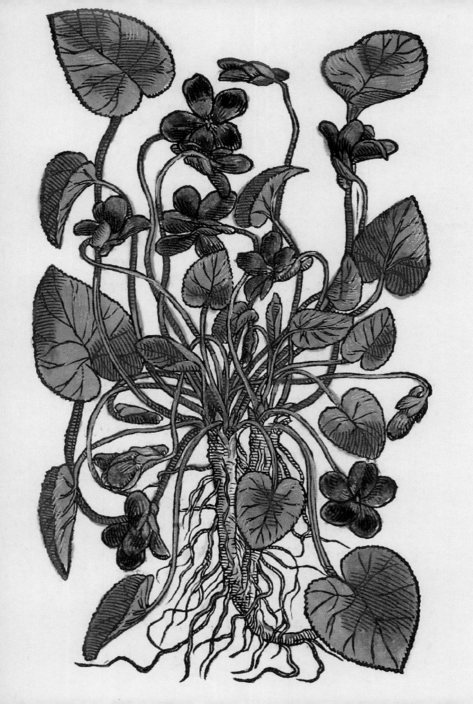

Purple violets in Pierandrea Mattioli's 1558 edition of *Commentarii*, published in Venice. This copy has been hand-coloured for a client.

RSL: *Commentarii*, p.574 (R.R.x.286)

The sweet violet, *Viola odorata*, and the Parma violet, a double form, are members of the Violaceae family, of which there are at least 700 species, growing naturally in all parts of the world apart from the tropics. The violet is a close relative of *V.tricolor*, also known in England as the pansy. The two are distinguished by the structure of their stipules, the leafy appendages at the base of the stem. The garden pansy has relatively large blooms in a wide range of colours, while the violet is small and delicately coloured in purple or white. Traditional local names for the pansy, or heartsease, include Kiss Me Behind the Garden Gate (Norfolk) and Meet Her in the Entry, Kiss Her in the Buttery (Lincolnshire). So once again, sex rears its head. How these names arose is not clear, but William Turner in his herbal of 1548 referred to the flower as Two Faces in a Hood, as if the two side petals were kissing within a hood of the upper and lower petals, so that the kiss gave ease of heart, hence heartsease. An alternative was Three Faces in one Hood with the suggestion that one of the lovers was superfluous to requirements, hence yet another name, Love in Idleness. This last name was given by Shakespeare to the flower whose juice was squeezed by Oberon into Titania's eyes so that she fell in love with the weaver Bottom transformed into an ass in *A Midsummer Night's Dream*, written in 1595 or 1596. The French for the flower was *pensée*, which may be the derivation of pansy, used in English from at least the beginning of the sixteenth century.

Britain has more native violets. The Dog Violet, which has no scent, covers several species including *V.canina*. Dog in this context means an inferior species, as with Dog Roses, and was so used by Gerard. Local names covered a wide range, from Hedge Violet and Blue Mice, through to Hypocrites, and Shoes and Stockings. Several included cuckoo – Cuckoo's Shoe, Cuckoo's Stocking and these may have been Celtic in origin. Another native is the Mountain Pansy, *V.lutea*, which grows naturally in Yorkshire, Northumberland, and the Lake District. Gerard was disappointed at how it would wither away and pine when grown in gardens: 'The Yellow Violet is by nature one of the wilde Violets, for it groweth seldome any where but upon most high and craggy mountains.'

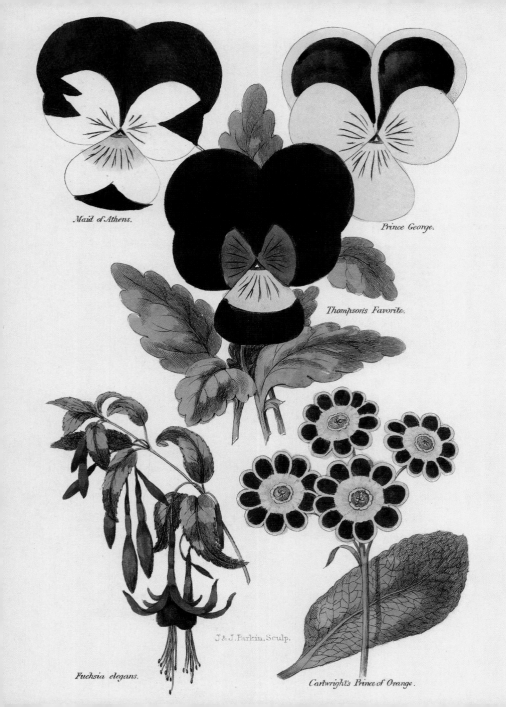

Maid of Athens.

Prince George.

Thompson's Favorite.

J. & J. Parkin, Sculp.

Fuchsia elegans.

Cartwright's Prince of Orange.

Pansies from Joseph Harrison's *Floricultural Cabinet*. Harrison was for several years head gardener to Lord Warncliffe at Wortley Hall near Sheffield in Yorkshire, before taking journalism. In 1833 he began publicat of the *Floricultural Cabinet*, a monthly journal that embraced everything use in horticulture, natural history, and rural economy. This turned out to be winning formula, selling nearly 60,0 copies in the first year, and continuin in print until 1859. The pansies show here included 'Thompson's Favourite – probably raised by the 'Father of Heartsease' – along with a fuchsia an polyanthus. They show how the heart shaped flower is becoming increasing stylised. See also p.151.

PS: *Floricultural Cabinet*, vol. 1 opp. p. 193

Heartsease, or the wild pansy, remained virtually unchanged in form until 1810. In that year it caught the fancy of T. Thompson, gardener to Admiral Gambier at Iver in Buckinghamshire. By crossing *V.tricolor* with the yellow *V.lutea*, and possibly also with *V.altaica* from Russia, he developed the garden pansy that is familiar today. He transformed the small, heart-shaped flower, which was known to florists as 'horse-faced', into a much larger, circular shape, and replaced the dark lines leading to the eye with a dark blotch. He also produced the wide range of rich colours that make the pansy such a useful garden flower. Mr Thompson became known as the 'Father of Heartsease' as a result of his endeavours.

The new form of pansy was developed by other English gardeners during the next decades, and duly joined the ranks of the florist's flowers in the 1830s. While the weavers of Paisley specialized in pinks and the cotton workers of Lancashire in auriculas, it was the miners of Yorkshire and Derbyshire who concentrated on pansies. But by this period the small competitions arranged by the florists' societies were dying out, to be replaced by new, local horticultural societies, covering a wider range of plants, including many exotics. The Horticultural Society of London, which had been founded in 1804, held its flower shows at its garden in Chelsea during the 1830s and 1840s. Twenty years later it had become the Royal Horticultural Society, with its garden in Kensington. The people who competed at these shows were both amateurs, like the florists, and professionals, nurserymen and gardeners working for upper- and middle-class employers. In the bigger horticultural societies, an element of snobbery developed, with special categories for 'cottagers', to encourage them to lift themselves 'out of the degrading habits of pauperism'.

The first garden violas were produced in the 1860s, when the Scottish nurseryman James Grieve crossed pansies with *V.cornuta*. Pansies, and the new garden violas, were ideal flowers for the mass bedding so

beloved by the Victorians. This was not the kind of gardening that found favour with William Robinson, who instead recommended in his *Wild Garden* growing the Bird's Foot Violet of North America (*V.pedata*), the Dogstooth Violet (*Erythonium americanum*), as well as 'our own sweet Violet' in as natural way as possible, 'in half-shady places, rocky spots or banks, [and] fringes of shrubberies'.

The term florist, that for centuries had signified a dedicated cultivator of flowers, took on a new meaning in the nineteenth century. John Claudius Loudon explained in 1822 that this second use of the term applied to 'market florists' who sold nosegays and potted flowers. The selling of nosegays on city streets enjoyed a long tradition: in seventeenth-century London, women would offer them to the fashionable beaux in Hyde Park. Henry Mayhew in his survey of London labour in the mid-nineteenth century described how flower-girls with large bundles of violets under their arms ran through the piazza at Covent Garden in the early morning, leaving a trail of perfume behind them. Many of these 'girls' were in fact elderly married women, who would buy a basket known as a shallow for 1s. 6d., or hire it for a penny a day. When the violets arrived in London, the sellers sat on the piazza doorsteps or on their upturned baskets, making their button-holes. The popularity of the violet for nosegays may be attributed to their beautiful deep colour that complemented all the elaborate stages of mourning observed by upper- and middle-class Victorian ladies, from black, through grey, lilac and mauve.

In the equally elaborate language of flowers, the blue violet signified humility, modesty, and faithfulness in love; the white, modesty and innocence. It is therefore remarkable that the violet is also associated with the Emperor Napoleon Bonaparte, who is not often described as possessing these qualities.

Four pansies from Harrison's Floricultural Cabinet for 1838. The flowers have become almost circular in shape in comparison to those shown on p.148.
PS: *Floricultural Cabinet*, vol. 6 opp. p.121

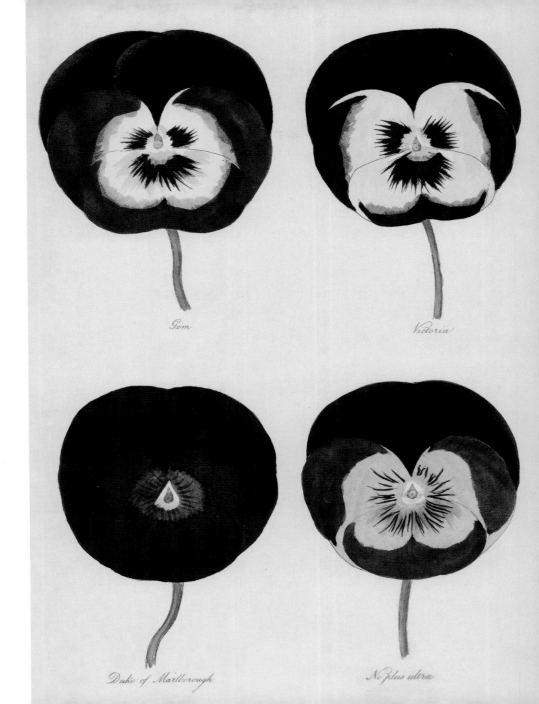

Gem

Victoria

Duke of Marlborough

No plus ultra

JANE LOUDON

Right: an arrangement of violas, pansies, and violets from Jane Loudon's *Ladies' Flower-Garden of Ornamental Annuals*, published in 1840. The illustration includes the wild pansy, *Viola tricolor*, the mountain pansy, *Viola lutea*, and various cultivars. Jane began her writing career as the anonymous author of *The Mummy! A Tale of the Twenty-Second Century*, which appeared in 1827. In this remarkable work of science fiction she referred to a steam mowing device, the telegraph and other innovations that prompted the botanical writer and garden designer John Claudius Loudon to give the book a favourable review and to seek out the author, whom he assumed to be a man. Within a year of meeting, they married and Jane began to hone her skills in botanical writing by helping him with his *Gardener's Magazine*.

When John Claudius ran into financial problems, Jane decided to tap into the market for books popularizing horticulture and botany for women. In 1840 she produced *Instructions in Gardening for Ladies*, selling over 1,000 copies on publication day alone, and *The Ladies' Flower-Garden* where, ever the innovator, she laid out the pages of illustrations in an artistic style that would encourage botanizers. She very much identified with readers who lacked science education, writing in *Botany for Ladies*, published in 1842: 'It is so difficult for men whose knowledge has grown with their growth, and strengthened with their strength, to imagine the state of profound ignorance in which a beginner is, that even their elementary books are like the old Eton Grammar, when it was written in Latin.'

PS: *The Ladies' Flower Garden* — page of pansies and violas, opp. p.85

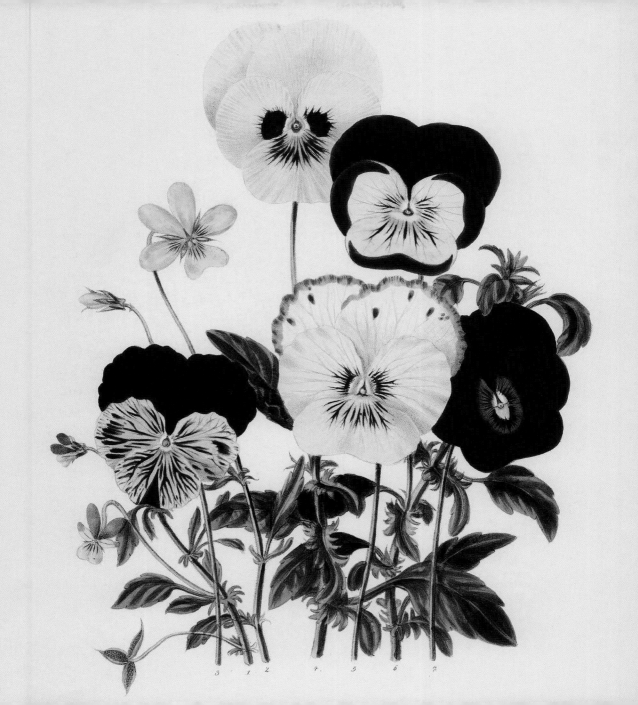

3 1 2 4 5 6 7

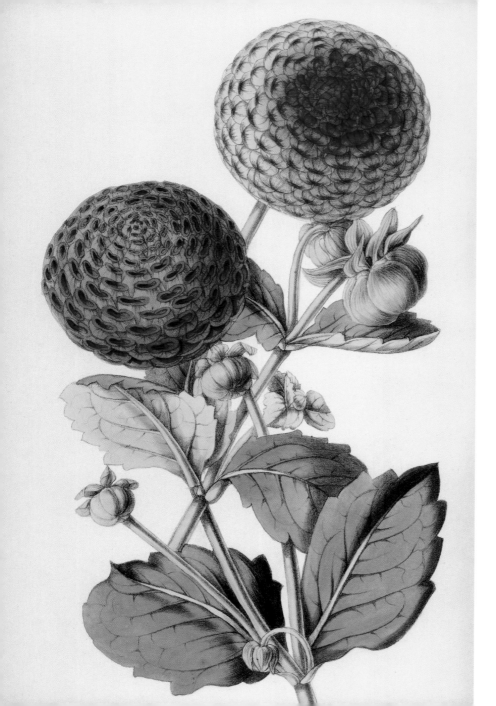

Pompon Dahlias from the 1865 edition
of the periodical, *Florist and Pomologist*.
The text records, 'Within the last year or
two there has appeared in our gardens a
race of Dahlias which has been variously
designated Bouquet Dahlias, Liliputians
and Pompons.' 'Star' was a bright orange
yellow, 'Little Dorrit', named after the
eponymous heroine of Charles Dickens's
novel of 1855–7, a deep, purplish rose.
RSL: *Florist and Pomologist*, 1862, opp. p.65
(Per.19185 d.62)

The Dahlia

The Ottoman Turks provided a botanical treasure trove for Western Europe during the sixteenth century, with precious bulbs such as the tulip and the narcissus. But there was another source of botanical riches, this time coming from the West. When the Spanish arrived in Mexico, they found a whole series of strange plants being cultivated in the gardens of the Aztec capital. These gardens were vast, laid out in regular squares separated by paths, with the flowers carefully arranged in categories. It has been suggested that the first modern botanic gardens, established in Italy in the 1540s, were inspired by the Aztecs.

Wonderful plants were shipped eastwards, and the excitement engendered by these is reflected by the fact that one, *Mirabalis jalapa*, was known as Marvel of Peru in England. The name was first used by Gerard translating from the Spanish, *Maravilla del Peru*, probably a reference to the fact that these South American flowers that opened at night to enable pollination by moths came in a variety of colours and produced a wonderful evening scent. Other imports from New Spain included the datura, the passionflower, and the tomato. But for one flower, the dahlia, the moment of glory was slow to arrive. Discovered in Mexico in the 1570s by the Spanish physician and naturalist Francisco Hernández in the 1570s and named as 'acocotli' and 'chichipathi' in his book, the flower did not arrive in Europe or gain its modern name until the end of the eighteenth century.

The rediscovery was made by a French botanist, Nicholas Thierry de Menonville, who had been sent to Mexico to discover the secret of how the Aztecs had cultivated the cochineal insect. He reported seeing 'acocotli' growing in gardens, and in 1789 sent back seeds to Europe. The Abbé Cavanilles,

director of the Royal Gardens in Madrid, began to cultivate the flowers, carefully crossing and selecting them to create a palette of different colours and forms. As neither acocotli nor chichipathi trip lightly off the European tongue, he called the new plant 'dahlia', after the Swedish botanist Andreas Dahl, adding *pinnata*, a description of the wing-like leaves.

At this time the Marquis of Bute, son of the botanical Earl (p. 130), was the British ambassador to Spain. Although his wife took an interest in the dahlia, and obtained seeds, these did not survive the journey from Spain. It was Lady Holland who proved successful in raising the first dahlias in England, in 1804. Meanwhile Josephine de Beauharnais was one of the sponsors of the scientists Alexander von Humboldt and Aimé Bonpland in their travels through Mexico, the Central Americas, and Colombia. The Botanic Garden in Berlin received seeds from Humboldt in 1804, from which fifty-five cultivars flowered, and with the enthusiastic support of the Empress at Malmaison the dahlia at last burst upon the European botanical scene.

In 1822 John Claudius Loudon described the dahlia as 'the most fashionable flower in the country', and by the 1830s a dahlia frenzy had begun, approaching in fervour the tulipomania of two centuries earlier. It became a florist's flower, with the traditional calendar of shows and feasts being adjusted accordingly: auriculas in April; tulips and anemones in May; ranunculus and pinks in June; carnations in August; and dahlias and chrysanthemums ending off the year, celebrated by the annual feast.

The enthusiasm for dahlias can be detected in the literature of the 1830s. The horticulturalist and writer Joseph Harrison launched his monthly magazine, *Floricultural Cabinet*, in 1833, and provides a useful indicator of what was really popular at the time: tulips, pansies, and dahlias throng the

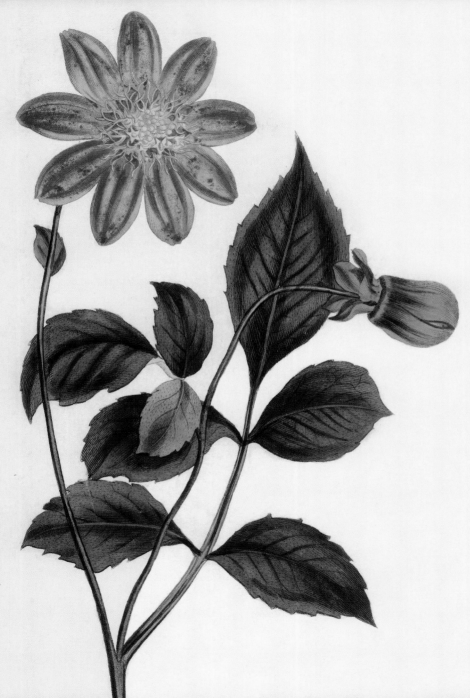

Dahlia coccinea, illustrated in *Curtis's Botanical Magazine*, 1804. This was one of the first images of the dahlia to be reproduced since the woodcuts from the 1651 edition of Hernández's book (p. 163).

PS: *Curtis's Botanical Magazine*, vol. 20 (1804), tab 762

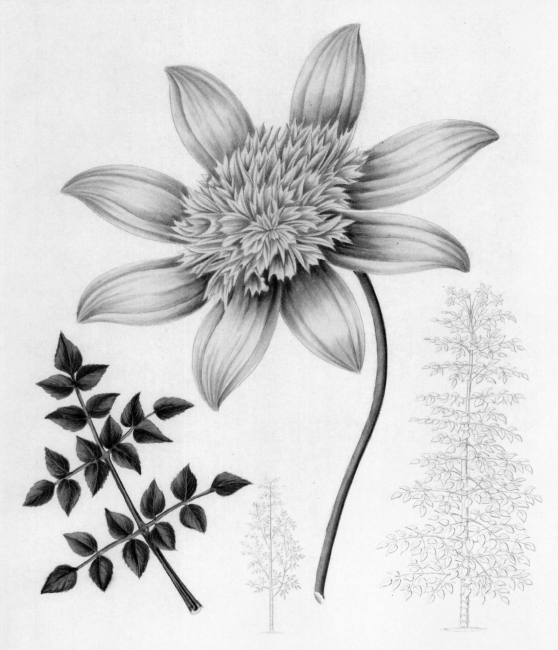

Mell S Manet. del. *Dahlia excelsa.* Nevitt sc.

pages. In the very first year, he published an article by a Nottinghamshire florist, 'On the Culture of the Dahlia', which begins:

> Having very extensive journeys to take during the summer season through most districts of the kingdom, my travelling is made of a very agreeable character by observing the very general taste for the cultivation of flowering plants; and for the last ten years I have noticed every successive season a very apparent increase. Among the varied attractions in flowers, none has arrested my attention so forcibly as the Dahlia in all its splendid varieties of colour and form, and no other plant of recent introduction has spread so rapidly through the country, which is full proof of the superiority of the flower.

With the requirements of shows, different categories of dahlias were developed. The ideal to aim for was the ball shape, with a sphere of geometrically arranged petals. These were known as Show Dahlias or Fancy Dahlias. By 1870, with interest in these on the wane, the National Dahlia Society was formed, and a tiny ball type was introduced and christened the Pompon.

The Tree Dahlia, *Dahlia excelsa*, from the second volume of Benjamin Maund's *Botanic Garden*. Maund, a keen botanist, ran a business in Bromsgrove High Street, where he combined bookselling, stationery, printing, bookbinding, and a pharmacy. His great work was *The Botanic Garden*, produced in thirteen volumes between 1825 and 1851, made up from monthly issues with engraved and hand-coloured figures of hardy ornamental flowering plants. Maund explained that the Tree Dahlia, which was unknown to the Spanish botanists and Humboldt, arrived in England *c*.1830 through an accident. The celebrated nursery of Loddiges in Hackney found that thick stakes sent as protection with an assignment of plants from Mexico showed signs of life and were therefore planted. They promptly grew to ten feet in height, though their susceptibility to cold meant that they did not produce flowers. In Mexico, on the other hand, they attained thirty feet in height, with lots of blossoms, 'an object quite worthy of the contemplation of the most zealous Dahlia fancier'.

PS: *The Botanist*, vol. 2

In 1872 the Dutch nurseryman M. J. T. van der Berg received a box of miscellaneous seeds from a friend in Mexico. One dahlia tuber survived against the odds, producing a brilliant red flower with petals rolled back and pointed, set on a tall stem. This he named a Cactus Dahlia, with the first cultivar 'Juarezii' in honour of the president of Mexico. Strangely, its origins are unknown, for no example has been discovered in the wild. Other types followed, including the Decoratives, which became a very popular show flower and the Collarettes, with their distinctive collar of a contrasting colour.

The brilliant colours of dahlias made them good candidates for the massed bedding that was so fashionable in the nineteenth century. John Fleming, the head gardener to the Duke and Duchess of Sutherland, laid out a series of parterres at Cliveden in Buckinghamshire in the 1850s. He claimed in a book published in 1870, *Spring and Winter Flower Gardening*, that he had created a revolution in gardening. Unlike his predecessors, who had to rely on evergreens and bare beds during the winter months, he began to bed out in the autumn plants and bulbs that would overwinter in the beds to provide a spring display, when they would be replaced by summer flowers that had been protected in the greenhouse. The vital factor was to produce solid blocks of colour that could be enjoyed from the house or terrace. The spring flowers might include tulips, forget-me-nots, and jonquils. The later colour would be provided by the 'hot' hues from Mexico: dahlias, cosmos, zinnias, and lobelia, and – from South Africa – gazanias and pelargoniums. The brilliant effect of mass bedding of dahlias can be seen today at Anglesey Abbey. When the display of hyacinths is finished (p. 99), Old Father Time presides over hundreds of dahlias, red 'Madame Simone Stappers' combined with gold 'Ella Britton'.

The Victorians also planted dahlia walks, a rare surviving example of which can be seen at Biddulph Grange Garden in Staffordshire. The garden at Biddulph was the creation of James and Maria

Bateman, a true gardening
marriage of two wealthy and
knowledgeable horticulturalists.
Among the components of
their remarkable 'world image'
garden, they created a Dahlia
Walk, with blocks of bold
colour divided by buttresses of
yew. The National Trust has
recently recreated this, using
the ball-shaped hybrid dahlias
that were the very height of
fashion in the 1840s.

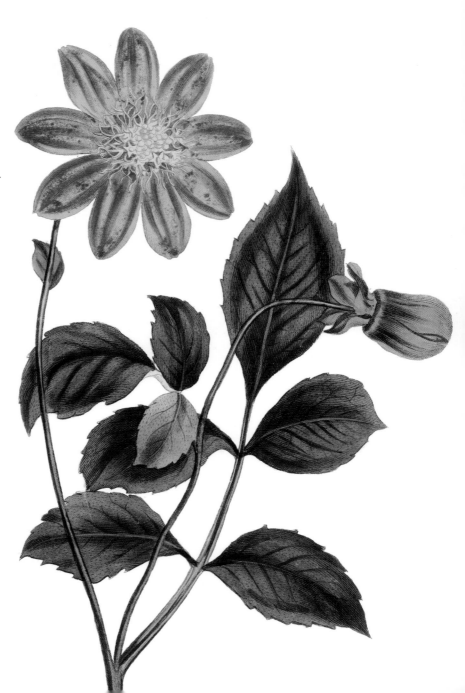

FRANCISCO HERNÁNDEZ

In 1570 Francisco Hernández de Toledo, personal physician to the King of Spain, Philip II, was dispatched to the Americas, charged with the task of mounting the first scientific mission. For seven years he collected and classified specimens in order to write a book describing the plants and animals of New Spain, with illustrations made by three indigenous artists. However, his *Plantas y animales de la Nueva Espana* was published in Mexico only in 1615, after his death, and it was not until 1651 that an illustrated version, *Nova plantarum, animalium et mineralium Mexicanorum historia*, was published in Rome. The original drawings were then lost in a fire in the library of the Escorial in 1671.

Two illustrations in *Nova plantarum* were described by Hernández as 'acocotli' or 'chichipathi', both words meaning waterpipe, from two tribes with different languages, the Quauhnahuacenses and the Tepoztlanenses, both under the rule of the Aztecs. Although his illustrations, of single and double forms of the same plant, were probably drawn from examples cultivated in Aztec gardens, the plants originated in the mountains. They had pale red flowers rather like daisies, and glandular roots with a bitter, acrid scent that were used to treat colic, tumours, and heart problems.

nigrum colorem inclinante, acri, odoratoq. & ordine tertio ficco, atque cali-
do . Piperis vicem fupplere poteft , & pro Carpobalfamo, aut Carpefio fubftitui .
Roborat cor , ventriculumq. , vtero confert, flatum diffipat, obftructiones ape-
rit, vrinam & menfes euocat, frigus pellit, cholicis, & iliacis opitulatur, venerem
excitat, craffos, & lentos humores incidit , & concoquit . quin additis *Colopatli* ,
Coapatli, *Tzitzicaztli*, & *Ololiuhqui* , & applicata dorfo, ex refina, fluxiones
alui coercet, appetentiam excitat , iliacis confert , frigoriq. & aneurifmatim e-
detur . Nafcitur apud Copitlanenfes .

De *ACOCOTLI QVAVHNAHVACENSI,*
& *TEPOZTLANENSI. Cap. VI.*

ACOCOTLIS

ACOCOTLIS
alia Icon .

PLANTA, quam *Acocotli* Quauhnahuacenfes vocant, & *Chichipatli*, Te-
poztlanenfes , herba eft , folia ferens Nardi montani folijs fimilia , in-
quina tamen diuifa foliola , quorum aliqua funt finuofa . in extremis verò cau-
libus, qui dodrantales , tenues, ac teretes funt, ftellatos flores è pallido rube-
fcentes , radices binas glandibus pares in totidem fibras definentes , fufcas
extra, intrinfecus verò candidas . hæc ad fpeciem Liguftici videtur fpectare .
Nafcitur in montibus Quauhnacenfibus . Radix guftu odorata, amara, & acris
eft . calefacit & exiccat ordine tertio . eadem vnciæ vnius pondere deuorata
alui

Further Reading

Allen, Louise, and Walker, Timothy, *The University of Oxford Botanic Garden* (Oxford, 1995).

Blacker, Mary Rose, *Flora Domestica: A History of Flower Arranging 1500–1930* (London, 2000).

Blunt, Wilfred, and Stearn, William, *The Art of Botanical Illustration* (rev. edn, Woodbridge, 1994).

Bogaert-Damin, Anne-Marie, *Voyage au coeur des fleurs* (Namur, 2007).

Campbell-Culver, Maggie, *The Origin of Plants* (London, 2001).

Coats, Peter, *Plants in History* (London, 1970).

Duthie, Ruth, 'English Florists' Societies and Feasts in the 17th and early 18th Centuries', *Garden History*, 10:1 (spring 1982), pp. 17-35.

– *Florists' Flowers and Societies* (Aylesbury, 1988).

Elliott, Brent, *Flora: An Illustrated History of the Garden Flower* (London, 2001).

Genders, Roy, *The Complete Book of the Dahlia* (London, 1953).

– *Garden Pinks* (London, 1962).

Goldgar, Anne, *Tulipmania: Money, Honor and Knowledge in the Dutch Golden Age* (Chicago, 2007).

Grigson, Geoffrey, *The Englishman's Flora* (London, 1975).

Hanmer, Sir Thomas, *The Garden Book* (facsimile edn, London, 1933).

Harris, Stephen, *The Magnificent Flora Graeca: How the Mediterranean came to the English Garden* (Oxford, 2007).

Hobhouse, Penelope, *Plants in Garden History* (London, 1992).

King, R. W., 'The "Ferme Ornée": Philip Southcote and Wooburn Farm', *Garden History*, 2:3 (1974) pp. 27–60.

Jekyll, Gertrude, *Lilies for English Gardens* (new edn, Woodbridge, 1982).

Knapp, Sandra, *Potted Histories: An Artistic Voyage through Plant Exploration* (London, 2003).

Laird, Mark, *The Flowering of the Landscape Garden: English Pleasure Grounds, 1720–1800* (Philadelphia, 1999).

Leapman, Michael, *The Ingenious Mr Fairchild* (New York, 2001).

Mabberley, David, *Arthur Harry Church: the Anatomy of Flowers* (London, 2000).

Murphy, Graham, *Old Roses* (London, 2003).

– *Wild Flowers* (London, 2004).

Parkinson, Anna, *Nature's Alchemist: John Parkinson, Herbalist to Charles I* (London, 2007).

Parry, James, *Irises* (London, 2004).

Pavord, Anna, *Naming of Names* (London, 2005).

– *The Tulip* (London, 1999).

Potter, Jennifer, *Strange Blooms: The Curious Lives and Adventures of the John Tradescants* (London, 2006).

Robinson, William, *The Wild Garden* (London, 1870).

Sherwood, Shirley, *A New Flowering: 1000 years of Botanical Art* (Oxford, 2005).

Stout, Mrs Charles, *The Amateur's Book of the Dahlia* (London, 1922).

University of Oxford Botanic Garden, *A Catalogue of the Plants growing in the University of Oxford Botanic Garden and Harcourt Arboretum* (Oxford, 1999).

Wulf, Andrea, *The Brother Gardeners: Botany, Empire and the Birth of an Obsession* (London, 2008).

Index